IMAGES
of America

CLEVELAND'S
ROCK AND ROLL ROOTS

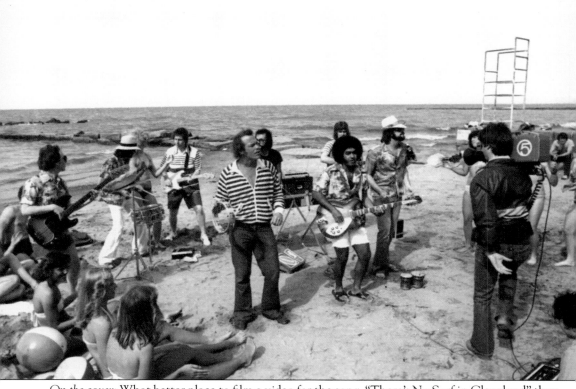

On the cover: What better place to film a video for the song, "There's No Surf in Cleveland" than right on the Lake Erie shore? The 1978 song was a regional hit for The Euclid Beach Band, but also caught the attention of the group they used as inspiration—The Beach Boys—whose singer, Mike Love, was a big fan. (Photograph by Bob Ferrell.)

*To my husband Jeff, for his steadfast support and unwavering love—
for rock and roll, as well as for me.*

*And to my brother and musician, Dennis Fedorko, who was my first
influence and teacher on all things rock and roll and who passed away
before the publication of this book.*

IMAGES
of America

CLEVELAND'S
ROCK AND ROLL ROOTS

Deanna R. Adams

ARCADIA
PUBLISHING

Published by Arcadia Publishing
Charleston, South Carolina

Printed in the United States of America

Library of Congress Control Number: 2009932621

For all general information contact Arcadia Publishing at:
Telephone 843-853-2070
Fax 843-853-0044
E-mail sales@arcadiapublishing.com
For customer service and orders:
Toll-Free 1-888-313-2665

Visit us on the Internet at www.arcadiapublishing.com

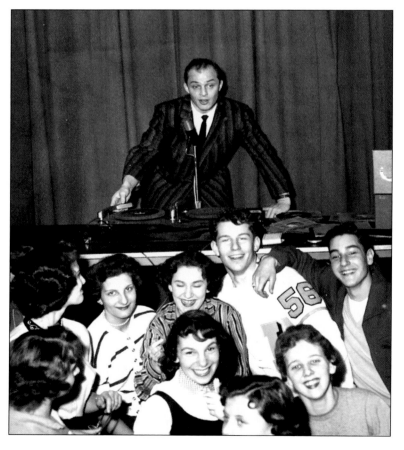

WERE-AM radio jock Phil McLean kept the music spinning at many teen sock hops, where the dances were all the rage, and so were the fashions—from McLean's sharp pin-striped suit to the high school boys' letter sweaters and girls' pearls and curls—and where everyone wore a smile. McLean hosted *Cleveland Bandstand*, a television dance show that aired from 1955 to 1960 on WJW, Channel 8. (Cleveland Press collection.)

CONTENTS

Acknowledgments 6

Foreword 7

Introduction 9

1. Blame It on the Deejays 11

2. Rockin' in a New Era 25

3. Radio Wars 39

4. Early Rockers 53

5. Clubs and Venues That Rocked 67

6. Blame It on the Deejays, Part Two 83

7. Rockin' Musicians of the 1970s 97

8. Genres of Rock, Cleveland Style 109

9. Musical Movers and Shakers 117

10. Hail, Hail Hall of Famers 123

ACKNOWLEDGMENTS

In 2002, my first book, *Rock 'n' Roll and the Cleveland Connection* was published after four years of painstaking research, cross-referencing, writing, and interviewing hundreds of rock deejays, musicians, club owners, and industry execs. I certainly had no desire to do another book on Cleveland's rock and roll history. But when editor Melissa Basilone contacted me and asked if I'd do this one for Arcadia Publishing—knowing it would be filled with unique and interesting images honoring the exciting history of my favorite town—well, I just couldn't resist.

It's been a fun adventure collecting photographs and reliving memories through them. Without these photographs, there would be no such book. So I begin by acknowledging those who entrusted me with their photographs so that they may be enjoyed by others. A heartwarming thank you to Jim Davison, John Gorman, Norm N. Nite, Billy Bass, Walt Tiburski, David Spero, Adam Spero, Brad Bell, Wally Gunn, Norm Isaac, Pat Kosovich, Ray Miller, Peanuts, Gene Schwartz, Chuck Dunaway, Ron Papaleo, Debbie Smith, Denny Carleton, Betty Korvan, Rich Spina, Rich Reisling, Diane Akins, Bill Buckholtz, Alan Greene, Mark Avsec, Rob Parissi, Eric Ochs, Chuck Rambaldo, Ken Constable, Jimmy Ley, Paul Fayrewether, Betty Beitzel, Bill Miller, Danny Sheridan, Denny Earnest, Carlos Jones, Tom Fallon, Mike Hudson, David Barnett, David Helton, Ernie Krivda, Steve Popovich, Kim Miller, and professional photographers George Shuba, Janet Macoska, Fred Toedtman, and Bob Ferrell.

I've made many friends as a rock writer, making it especially difficult when some pass on too soon. A special, heartfelt recognition goes to the late Jim Girard, Dave Nida, and most recently, Brian Chalmers, who passed away during the making of this book. Brian was an artist/ photographer who always shared his wonderful images with others. While those images live on, it is the kind soul behind them that will be forever missed.

Much gratefulness goes to the staff at Cleveland State University Library's Special Collections Department, especially Lynn M. Duchez Bycko, who kindly made herself available to me in many ways. And of course, Arcadia book editor Melissa Basilone for giving me this opportunity and for her helpful assistance in the production of this book.

Finally, a shout out to the Rock and Roll Hall of Fame and Museum that graces our Lake Erie shore. The Rock Hall celebrates our musical legacy by illustrating it in a beguiling visual manner. As does this book.

FOREWORD

I moved here in 1973. One of my first impressions of Cleveland was that I couldn't get there from here.

Let me explain.

Nearly all cities have east, west, north, and south rivalries and separate identities—but nothing came close to what I experienced in Cleveland. People I'd meet from the west side rarely had been east of downtown, and the east-siders wouldn't consider venturing to the other side of the Cuyahoga River. In fact, I knew more east-siders that had been to New York than North Olmsted, and more west-siders who had been to Chicago than the diverse University Circle or the eclectic Coventry neighborhood in Cleveland Heights. Even those living within 10 to 15 miles of the southernmost borders of Cuyahoga County identified themselves as being either east- or west-siders with the snaking Cuyahoga River as its boundary.

Until I-271 and I-480 were completed, there were few ways to get from one part of Cleveland to the other. Being newly arrived from Boston, and having travelled extensively throughout most of the northeast and Canada, the experience of not being able to easily navigate around the city was baffling.

Another baffling aspect to this Boston native came courtesy of 1973 Cleveland's downtown-based sports franchises. Both the Indians and Browns had their best days behind them. Except for opening day or a promotion to keep a rivalry alive, neither team drew momentous crowds downtown.

I remember my first Indians game. It was the emptiest stadium I'd ever been in.

So what does this have to do with rock and roll in Cleveland? Plenty.

Rock and roll united not just the east- and west-siders, but also those south of Cleveland, in Akron and Canton. Rock and roll brought young people to downtown Cleveland for concerts. Until the Richfield Coliseum opened in 1974, downtown Cleveland was the sole neutral zone for year-round concert activity—Public Hall, Music Hall, and the Allen Theater were the main venues for national concert tours. There was also the Agora, on East Twenty-fourth, and the Smiling Dog Saloon on West Twenty-fifth, which booked national acts, too, but most were up-and-coming local artists and bands. These bands served as ambassadors for their isolated regions, and played the local clubs on both sides of the river—with radio and print delivering the message.

When I knew I'd be moving to Cleveland, I reviewed its rock and roll and radio history. Those I knew in the radio and music business considered Cleveland a major breakout market for new music and that it had a rich musical history going all the way back to the big bands.

Everyone in the business knew the call letters of the era: WHK, KYW/WKYC, and WIXY. And CKLW, whose signal from Windsor, Ontario, was strong enough that, on rare occasions, I could hear it all the way in Boston.

I was familiar with many of the radio deejays of the 1960s. In Boston, some of them had also been on Cleveland radio, such as Al Gates and Chuck Knapp. I also knew of Johnny Holiday and Mad Daddy from hearing them on WINS New York, whose evening signal skipped up the Atlantic Ocean to Boston. And both the *Upbeat Show* and *The Ghoul* were carried on Boston television stations.

I also owned a few albums that were recorded at Cleveland Recording. These included a number of artists I liked: The Outsiders, The Raspberries, The James Gang, and even the Firesign Theater—all I learned were based or rooted in Cleveland. And one of my favorite guitarists from that era, Glenn Schwartz, who I'd seen perform with Pacific Gas and Electric, was also from Cleveland.

When I came to Cleveland to work at WMMS-FM, I was reunited with Denny Sanders, who I had worked with at a couple of Boston stations. Denny had moved to Cleveland a year and a half earlier, and told me a subsequent full-time job was open for me. In those early days at WMMS, we didn't have a promotion or marketing budget and had to rely on grassroots promotion and guerilla marketing. We offered to sponsor and promote anything and everything—just to get visibility for our call letters—and pitched clubs, student unions, concert promoters, and movie theaters for cosponsorships. Our staff was made up of mostly Cleveland natives. That alone was unheard of in radio circles where most radio was staffed like sports teams, mostly out-of-towners.

And Cleveland's musical tastes were quite diverse, which allowed us to play a wide variety of musical genres and styles on our counter-cultural rock format. And the acts loved playing Cleveland. This town knew their music—even the latest releases—and, unlike either coast, where the "too cool" would sit on their hands, our audiences were on their feet, punching their fists in the air, and singing along!

Throughout the 1970s, more rock and roll albums were sold per capita in the Greater Cleveland–Akron market than any other region in the country. There were concerts booked in downtown venues nearly every night of the week. Clubs hosted WMMS-sponsored "nights out" featuring the best up-and-coming new music talent. And diverse bands like Kiss, Lynyrd Skynyrd, The Police, Duran Duran, the New York Dolls, Bad Company, Boston, and AC/DC played their first Cleveland date at one of our sponsored club nights out.

When it came to rock and roll, Cleveland was what we called a well-oiled machine. We had the best promoters, venues, record stores, radio station—and most importantly—the best audience, which, when working in unison, made this city undeniably *the* "Rock & Roll Capital of the World."

—John Gorman
music and program director and operations manager of WMMS from 1973 to 1986

INTRODUCTION

By now, you've all heard the phrase, and most probably the song, "Cleveland Rocks" even if you've never set foot on the southern shores of Lake Erie. But what does that mean? Cities all over the country can rock with the best of them. What makes Cleveland special?

The answer to that would take a book, or several, actually. So far, there are at least five that chronicle various aspects of this city's rich and colorful music history. My book, *Rock 'n' Roll and the Cleveland Connection*, was the first, but certainly not the last. That's because it's simply not possible to include everything, in one volume, that has taken place here in the past six decades that would do justice to this storied past. So I'm excited to bring yet another approach to this diverse and bountiful subject by using photographs to illustrate the energy, enthusiasm, and creative talent that have always been the nucleus of Cleveland rock and roll.

This history always meanders back to Alan Freed, the man who truly got the rock rolling. While there are only a few photographs of Freed and his days in Cleveland—and the Moondog Coronation Ball in particular—they are of historic value to any genuine rock music fan. This was truly the launch of a music trend that has never died, but rather expanded in hundreds of ways, and genres, like branches of a tree. In the 1950s and 1960s, Cleveland was particularly important to the record and radio industry. This lakeside city, sandwiched between New York and Chicago—two of the bigger, more influential forces in the industry—was a proven testing ground for new records. Why? Many of the major record labels, such as Columbia, RCA, Capitol, King, and Decca had warehouses in downtown Cleveland. And jukeboxes were the hippest item in every tavern and fast food eatery (like drive-in hot spots, such as Big Boy restaurants). Plus, there were the movers and shakers promoting those records, thus stirring up the town by introducing youngsters to an exciting new movement in popular culture: rock and roll music. Those astute personalities included a music-loving deejay, Alan Freed, and a record store owner, Leo Mintz, for starters.

The hub of this activity was Mintz's downtown record store, Record Rendezvous, where many teens hung out after school and on weekends. It was also during this time that Mintz met Freed, who had recently been hired as a disc jockey at Cleveland station WJW-AM. Mintz convinced the enthusiastic deejay to play some of the rhythm-and-blues records that his young customers were rocking and rolling to each day in his store. Which sparks the question about the phrase itself. The term, rock and roll, was not new, having been used as sexual innuendo since the 1930s (and in The Domino's 1951 hit, "Sixty Minute Man"). Mintz is believed to have described the kids dancing to the music (then referred to as "race" or "colored" music) by "rockin' and rollin' " to the various tunes. So when Freed started playing these records on his

popular late-night program, "The Moondog Show," the deejay began referring to this sound as "Rock 'n' Roll." This inspired an idea. A rock 'n' roll extravaganza: The Moondog Coronation Ball. Taking place at the Cleveland Arena on March 21, 1952, what became known as the first rock 'n' roll concert was less than successful, due to an overselling of tickets resulting in an unhappy mob that couldn't get in, forcing the concert to close soon after it began. Ironically, this public relations disaster that made the front pages of both the *Plain Dealer* and *The Cleveland Press* resonated perfectly with the rebellious nature of the music itself.

From there came a long list of rock deejays, bands, and solo musicians who shook up the dance halls and concert venues in Cleveland, Ohio. And while it may have all started in the 1950s, it was the 1960s and 1970s that permanently embossed this city to rock and roll music. But then, who coined the phrase, "Rock 'n' Roll Capital of the World?" Leave it to another Cleveland deejay to be the impetus of that.

"Back in the early '70s, Cleveland had a terrible reputation," recalls former deejay Billy Bass. "There was nothing happening here that made us look good. The Indians weren't doing great, nor were the Browns . . . and people were *still* talking about the river catching fire [in 1969]. There was nothing to be proud of—except our radio! Clevelanders loved, and *knew*, their music." This reputation was confirmed by a 1979 *Wall Street Journal* article proclaiming Cleveland as the "Rock Music Capital of the World," citing top record sales, The Agora Ballroom's openness to innovative music acts, and the impact radio stations like WMMS had on the listeners, often breaking new artists onto the national music scene. That same year, British rocker Ian Hunter paid homage to his favorite town by writing the song "Cleveland Rocks" that served to underscore this city's status.

In the 1960s, Cleveland rock 'n' roll expanded to television and print media (until then, reporters refused to acknowledge the music genre) and was a popular presence in a variety of teen and adult clubs, and outdoor venues. By the 1970s, rock music was a bona fide lifestyle. But like the subsequent demise of vinyl records, black-and-white television, and eight-track tape players, this musical spirit has evolved into today's contemporary fabric, leaving many to mourn the sounds, and trends, of yesterday.

But through these photographs, posters, and ads, this book demonstrates the innovation, attitude, and perseverance that have long been staples among Clevelanders, be they sports fans or rock 'n' roll enthusiasts. In this manner, these images capture the ingenuity of the savvy and enthusiastic behind-the-scenes men and women who worked hard to make things happen. This is the story of the early days of Cleveland rock history. But it's not the whole story. As I write this, Cleveland is hosting the 24th annual Rock and Roll Hall of Fame Induction ceremony. Certainly a lot has happened before and since then. There are thousands of stories, artists, events, and influences that have made rock and roll what it is today. It is precisely that legacy that must be honored like a wise grandparent. And it's those youthful days that are most fun to look back on. A worthwhile journey, not only to reminisce, but to learn and respect a past that was indeed great. And which continues to influence future music-loving generations.

Cleveland's Rock and Roll Roots honors what came first, who brought the changes, and how it all transpired, documented through a glorious photographic celebration of this North Coast's musical past. It's like flipping through a family album you can revisit again and again.

Huey Lewis was right, the heart of rock and roll is in many cities.

But its soul is in Cleveland.

One

BLAME IT ON THE DEEJAYS

At Akron's WAKR, Alan Freed earned a loyal following by playing music from "pop to the cool jazz bit" with some classical music, and, reportedly, a few rhythm and blues (R&B) records in between. When management refused to give him a raise, Freed high-tailed it to Cleveland station WJW-AM, where he began calling the R&B records he played, "Rock and Roll." His years in Cleveland—1951 to 1954—ignited his career. (Jim Davison collection.)

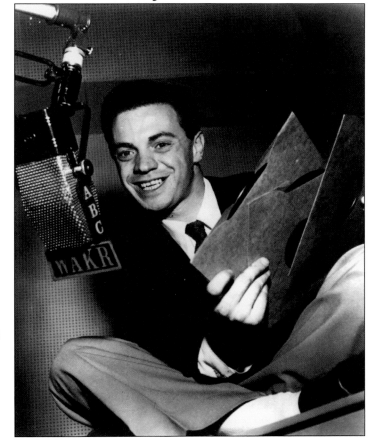

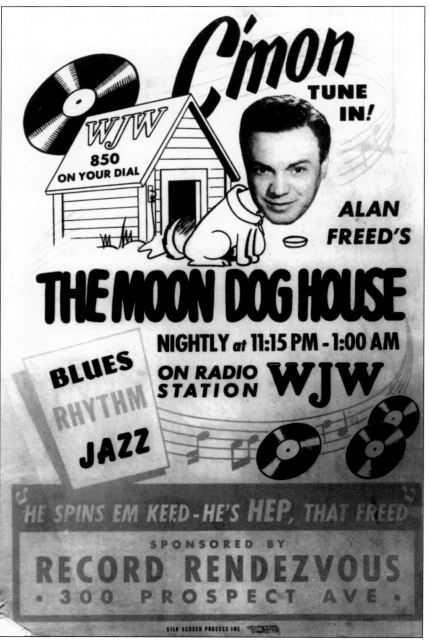

Record Rendezvous owner Leo Mintz was a major sponsor at WJW-AM radio and hired Alan Freed to spin some of the R&B records that were gaining teen interest in his downtown Cleveland record store. Freed's nighttime *Moondog Show* debuted on July 11, 1951, and fast became the hippest radio program on Cleveland airwaves, not only due to the records this new deejay played but also his driving, energetic voice and style. (When he played the R&B tunes, his voice would yell in harmony to the bluesy saxophone as his hands pounded out a rapid beat on a thick Cleveland telephone book). Freed, the "King of the Moondoggers," soon became the monarch of all things rock 'n' roll. (Janet Macoska collection.)

This poster, promoting what is now considered the first official rock and roll concert, The Moondog Coronation Ball, promised a rousing good time. But organizers Alan Freed, Record Rendezvous record store owner Leo Mintz, and promoter Lew Platt ended up with too many tickets, ultimately overselling the event. This of course created havoc, and within an hour, the Arena was indeed rockin' and rollin'. Thus, a good time was not had by all. Few photographs exist from that historic event since the media dismissed rock and roll as a fad destined for a quick death. (Eric Ochs collection.)

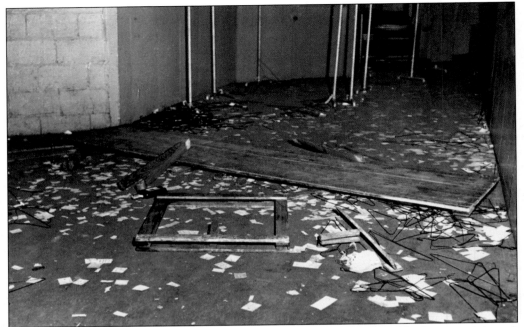

The first rock concert became the kind of smashing event Alan Freed had not anticipated. Frustrated concert-goers began breaking down doors when they could not get into the Cleveland Arena. The fire marshal shut the concert down, disappointing fans and promoters alike. Calling it the "Blues Ball Brawl," *The Cleveland Press* front-page article read, "Hepcats jammed every inch of the big Arena floor, took every seat, filled the aisles and packed the lobby and sidewalk, overflowing into the streets . . . a crushing mob of 25,000 blues fans were forced to disperse." The front page of the *Plain Dealer* stated reports of a willful advance oversell, adding fuel to the already growing disdain for rock and roll. By the end of the rowdy night, all there was left were broken vinyl records, bottles of booze, and dancing shoes. (Cleveland Press collection.)

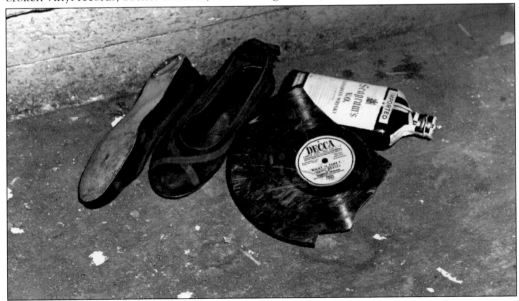

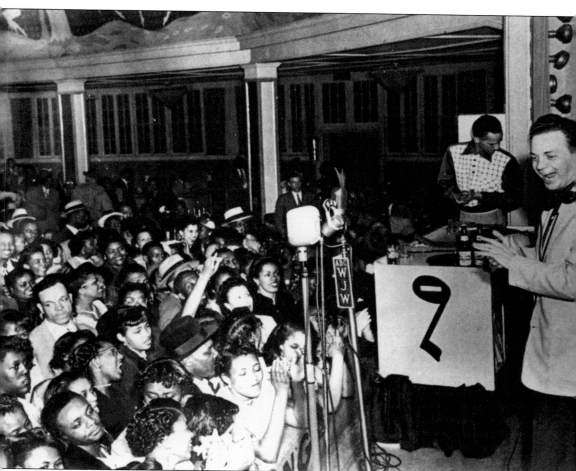

Despite the Moondog disaster, Alan Freed continued hosting "rock 'n' roll extravaganzas" and sock hop dances throughout his career. Freed left Cleveland in 1954 for New York station WINS, where he won thousands more fans, and national fame. He even became a movie star. The undisputed king of radio programming appeared in several movies, including *Rock Around the Clock* with Bill Haley and the Comets, and *Don't Knock the Rock* with Little Richard. But his controversial career took an irretrievable dive during the payola scandal (which ruined many careers of deejays who were accused of accepting bribes to play certain records). Although he had his share of critics, Freed loved rock and roll music and believed in its validity. "There's nothing critics can do to stop this new solid beat of American music from sweeping across the land in a tidal wave of happiness," he once said. The controversial deejay ultimately proved the naysayers wrong. (Janet Macoska collection.)

While Alan Freed was shaking up listeners at WJW, the more mild-mannered Bill Randle was "playing all the hits" over at WERE. These hit records were often those the "Kingmaker" made popular himself merely by his recommendation. Known for his great ear and intuition for good marketable music, Randle often played songs by unknown artists, first on this Cleveland station, then on New York station WCBS, where he hosted an afternoon show on the weekends. These records included "Sh-Boom" and "Earth Angel" by the Crew Cuts, "Why Do Fools Fall in Love" by the Diamonds, and "Born Too Late" by Cleveland singers The Poni-Tails. Indeed, after just a few spins on his turntable, the vinyl records would magically turn into gold. (Cleveland Press collection.)

The influential record spinner not only worked a full six-day week in Cleveland, then flew to New York each weekend for his WCBS Saturday afternoon show, he also somehow found time to emcee teen dances. He enjoyed introducing his audience to records by artists such as Pat Boone, Johnnie Ray, The Four Lads, and the soon-to-be rock and roll icon, Elvis Presley. (Cleveland Press collection.)

While Freed attracted more of a black audience, due to the R&B records he played, Randle's fans were decidedly more Caucasian, as were the recording artists. But once rock began merging with other music genres, it brought together people of all races and nationalities. While the music Randle touted was more subdued than Freed's, teens also came in record numbers to wherever this WERE deejay was, like this dance at Parma High School. (Cleveland Press collection.)

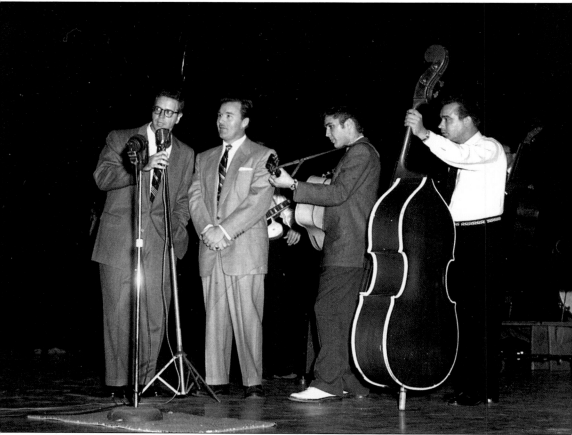

While Bill Randle hosted many teen dances, his most famous will always be this Brooklyn High School event. He, along with WERE radio colleague Tommy Edwards and booking agent Syd Friedman, brought in several musicians to perform at the school on October 20, 1955. The little-known Bill Black Trio (with singer Elvis Presley) shared the stage with Bill Haley and the Comets, the Four Lads, and headliner Pat Boone. An excited Randle told Boone, "I got a guy here who's gonna be the next big thing—Elvis Presley." After meeting the shy Southern kid, Boone had his doubts. On the other hand, Elvis was such a fan of Boone's, he went out that morning to Robert Hall's clothing store and purchased white loafers like his idol wore. After that performance and one that evening at St. Michael's Hall, everyone realized that, as usual, Randle knew what he was talking about. (Courtesy of David Barnett.)

Tommy Edwards was a country music deejay at WERE, and host of the *Hillbilly Jamboree*. Edwards played Elvis's first records on his program, prompting him and Randle to book the boy's band, the Bill Black Trio, at the Circle Theater on February 26, 1955. When Elvis returned to Cleveland that fall, he was a bone fide rock 'n' roll star. In 1960, Edwards was "let go" by new management, so he moved his show to Akron (seen above). Edwards loved all kinds of music. The deejay not only spun records, he also played music and recorded it. The 1957 narrated "What is a Teenage Girl?" and follow-up, "What is a Teenage Boy?" received quite a bit of regional airplay, but failed to shake up the industry. (Above, courtesy of Dave Nida; below, Cleveland Press collection.)

"The Jekyll and Hyde of Radio," Pete Myers turned into the eccentric Mad Daddy on his WJW late-night show. The deejay also hosted a television B-movie double feature and acted out scenes. Myers even "jumped in the lake" to advertise his switch to WHK in June 1958 (he parachuted down while screaming out his new call letters). His unique style was unforgettable. (Author collection.)

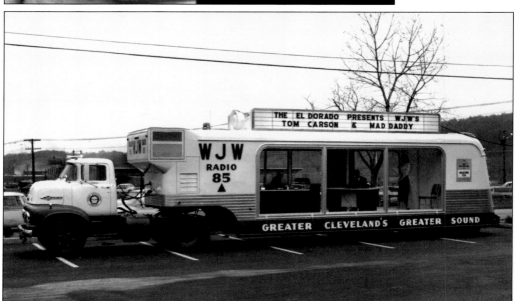

This WJW Mobile Studio, 45 feet in length, was the talk of the town in 1958 as it blasted the popular disc jockeys' voices, and the hit songs of the day, throughout the streets of Cleveland. Promotional wheels at its best! (Cleveland Press collection.)

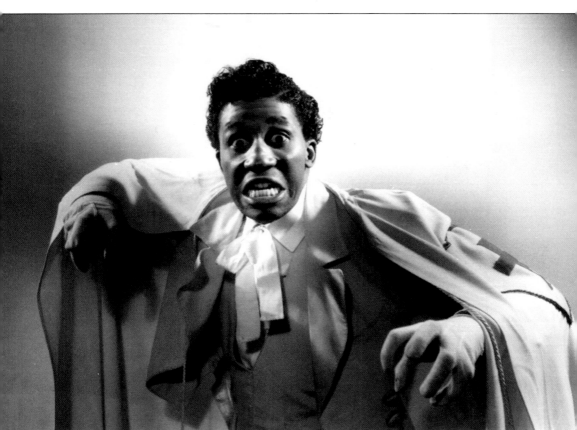

Mad Daddy most assuredly played songs by Cleveland singer Screamin' Jay Hawkins, like the hit record, "I Put A Spell on You." Screamin' Jay was known for his strange and legendary performances, such as being carried on stage in a coffin wearing voodoo-style black satin suits. He was often accompanied by "Henry," a cigarette-smoking skull on a stick. Other Hawkins songs included "Alligator Wine," Constipation Blues," and "Bite It." Indeed, this singer's songs and wild onstage antics were right up Mad Daddy's alley. (Courtesy of Norm N. Nite.)

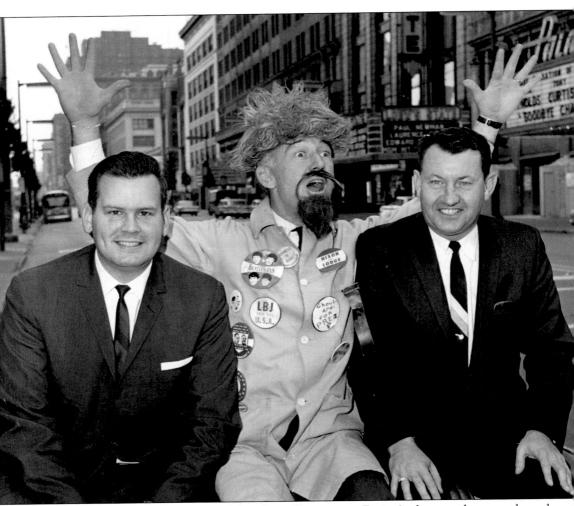

One deejay who was less successful than his colleagues was Ernie Anderson, who went through several station firings (he was not one to easily conform to management) before joining WHK. It was there that Anderson befriended Mad Daddy, who became such an influence on the young deejay that he later borrowed from Myers's madcap persona, becoming "Ghoulardi," and host of WJW's *Friday Night Shock Theater*. The Ghoulardi show became one of the biggest hits in Cleveland television history. His madcap style was an influence on future punk rock bands, such as The Cramps and Electric Eels. Although Anderson left for Los Angeles in 1966, he remains a legendary Cleveland figure to this day. Here, in 1964, Ghoulardi takes part in a parade for the Parma Jaycees (the city he often spoofed in his show's skits). (Cleveland Press collection.)

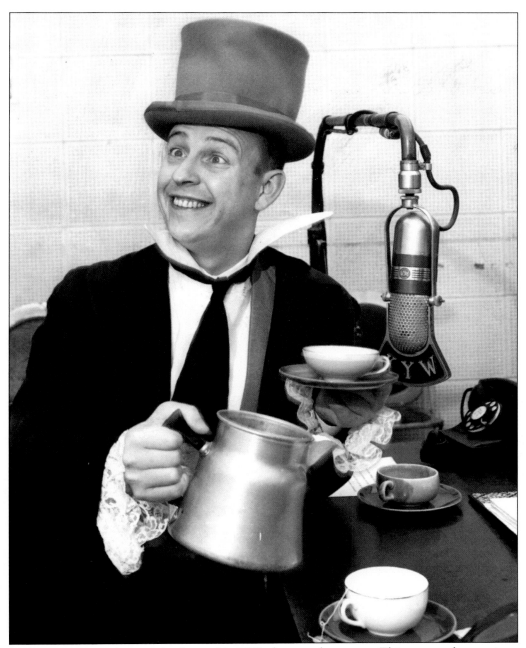

Joe Finan was not always as kooky as this 1957 photograph suggests. This top-rated, sometimes controversial personality wore many hats through his broadcasting career that spanned nearly 60 years. He was a popular deejay at KYW throughout the 1950s, but like many disc jockeys during that time, the payola scandal rocked his career in 1960 when he was indicted for playing records in exchange for extra gratuities. But Finan persevered, worked in other towns, and eventually returned to Cleveland airwaves in 1968 to work at the hottest radio station on the North Coast, WIXY-1260. He then developed the art of AM talk radio at Akron stations WNIR and later WARF, where he worked until his death in 2006 at the age of 79. (Cleveland Press collection.)

Casey Kasem arrived in Cleveland in 1959 to work at WJW. "I knew I'd better be as exciting and creative as he was," Kasem recalls after hearing Mad Daddy's show. *Casey at the Mike* played R&B in the tradition of Alan Freed. Now known for his *American Top 40*, Kasem credits his days in Cleveland for helping him develop his own signature style. (Courtesy of Casey Kasem.)

It was indeed all about the record—and the charismatic record spinners who influenced their listeners with their musical picks. This valentine to Cleveland ties in both. By the end of the 1950s, teens had their choice of radio stations, a slew of deejays to adore, and many places to enjoy their rock and roll music: television's *American Bandstand*, transistor radios, or hip record stores. (Jim Davison collection.)

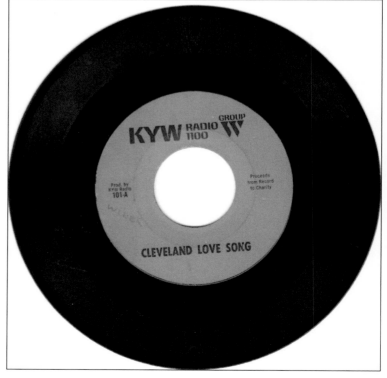

Two

ROCKIN' IN A NEW ERA

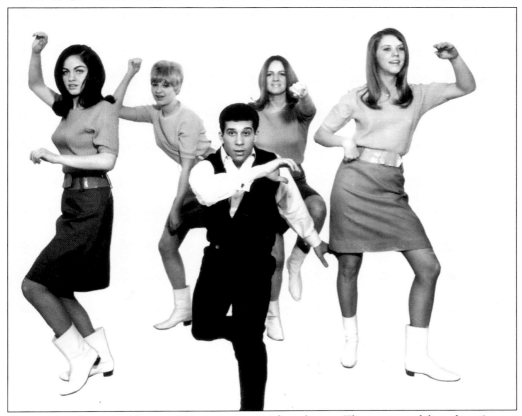

You were the hippest girl around if you were an *Upbeat* dancer. The program debuted on August 29, 1964, as *The Big 5 Show* and featured a slew of local and national stars. Producer Herman Spero knew the pretty "go-go dancers" from area high schools would help secure a ratings-guaranteed teen audience each week. While veteran dance instructor Dick Blake was the original choreographer, Jeff Kutash, seen here, took over from 1966 to 1970. (Photograph by George Shuba, Cleveland Press collection.)

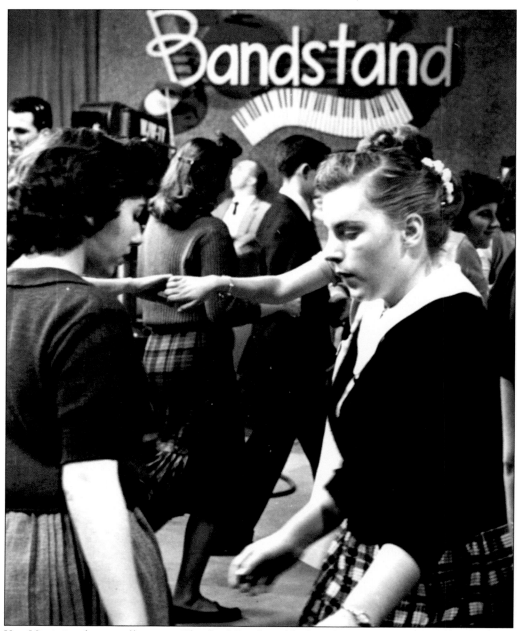

Yes, Virginia, there really was a *Cleveland Bandstand* before there was an *American Bandstand*. This local dance show aired on WJW from 1955 to 1960. Although the original host was WERE disc jockey Phil McLean, it could well have been Dick Clark. In 1955, the then 25-year-old radio announcer from Philadelphia called up the general manager at WEWS-TV suggesting a dance show like the one they were doing in his hometown (but which already had a host). The manager responded bluntly, saying he would never "put that kind of crap on the air." The manager over at WJW, however, was more open-minded and soon aired *Cleveland Bandstand*. And Clark ultimately got his dream job as host of *Philadelphia Bandstand*, which became the nationally syndicated hit show *American Bandstand* in 1957. (Cleveland Press collection.)

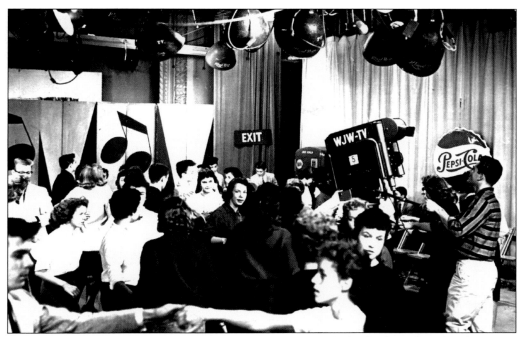

Teens all over town came to the WJW studios to be a part of *Cleveland Bandstand* and to swing to records by Buddy Holly, Bill Haley and the Comets, and of course Pat Boone (for the slower, romantic dances). The show's success was also due to its host calling up an audience member to pick out the next record to be played. In the photograph below, it appears this girl wants McLean to play an entire album. Before the show was cancelled in 1960 (it was unable to compete with the nationally syndicated program), Casey Kasem had replaced the departing McLean (who went to New York) during its last few months on air. (Cleveland Press collections.)

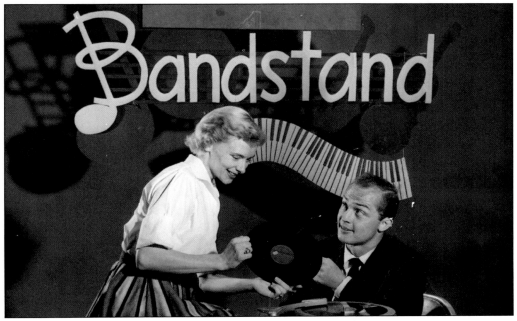

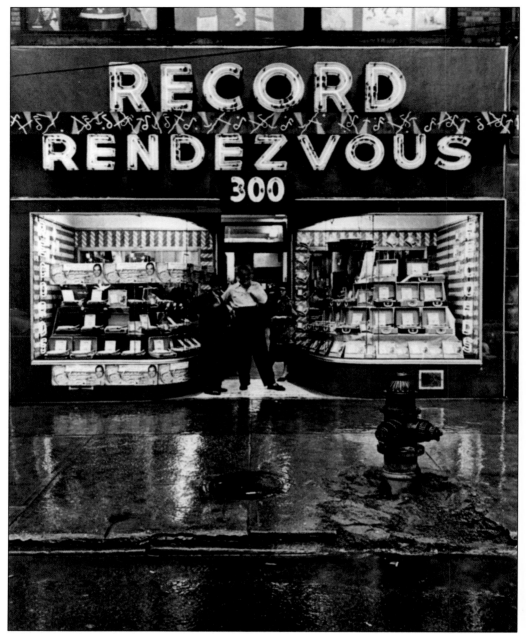

Of course without the records, there would be no rock and roll. After Alan Freed took his music and charismatic personality to New York, Clevelanders still had Record Rendezvous, the most popular downtown hangout for teenagers. The store continued to attract kids of all races and nationalities, who would arrive on streetcars and buses from all ends of the North Coast, east, west, and south sides of town, to get their fill of the R&B records that had them literally rockin' and rollin' in the aisles. Even a water main break would not deter Leo Mintz's music-loving patrons—they would simply have to put their galoshes on. (Janet Macoska collection.)

Leo Mintz catered to music lovers, no matter how young, knowing children become teenagers who would be sifting through the record bins in his store, or spend time in the "listening booths" (so customers could preview a record—long before bookstore chains). His ads boasted "From Bach to Bop," an all-together fitting adage for the broad scope of music Mintz provided. (Cleveland Press collection.)

If Mintz could not get certain records from the warehouses in town (and there were several, including Columbia, RCA, Mercury, and King Records), he would drive to Columbus to give his customers what they wanted. He opened other stores in the Cleveland area, but when he died in 1976, the stores, including his beloved one on Prospect Avenue, experienced changes, and by 1987, all the stores had closed. (Cleveland Press collection.)

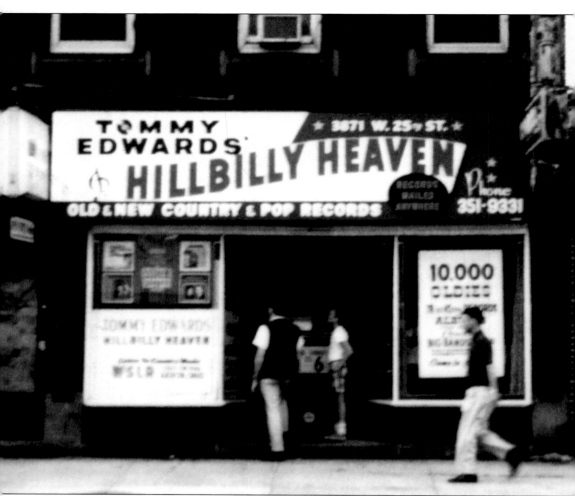

After Tommy Edwards left WERE, the deejay never returned to radio. Instead, he opened Tommy Edwards's Hillbilly Heaven record store on Cleveland's west side in 1962. The store offered an array of musical offerings: pop and rock records for his growing teenage customers, as well as rare and out-of-print records. And of course, as one who introduced "The King of Rock and Roll" to Cleveland, Edwards had the largest collection of Elvis records in town. The name changed to Tommy Edwards Record Heaven when he moved his store to Fulton Road in 1973. Edwards enjoyed introducing his customers to new sounds, catered to their needs, and made lasting friends. One of them was Chuck Rambaldo, who upon Edwards's death in 1981, bought the famous record store and continued its legacy for the next 26 years. (Chuck Rambaldo collection.)

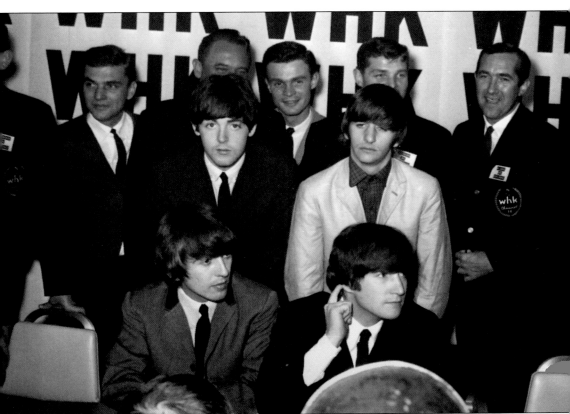

Then came The Beatles. The year was 1964 and local radio stations WHK and KYW battled furiously to be the ones to bring the famous group to Cleveland and be crowned the "Official Beatles radio station." Although KYW had the VIPs (very important personalities), they apparently did not have the promotional savvy that WHK had. After some behind-the-scenes maneuvering by WHK salesmen, the oldest station in Cleveland secured their prized status as sponsors of the Beatles' first Northeast Ohio appearance on September 15, 1964. In turn, their photographs were taken by a young college student and aspiring photographer named George Shuba, who had never heard of The Beatles until he was hired by WHK to capture the event that would go down in Cleveland's rock history. Since then, Shuba captured much of rock's royalty in his lens. (Photograph by George Shuba.)

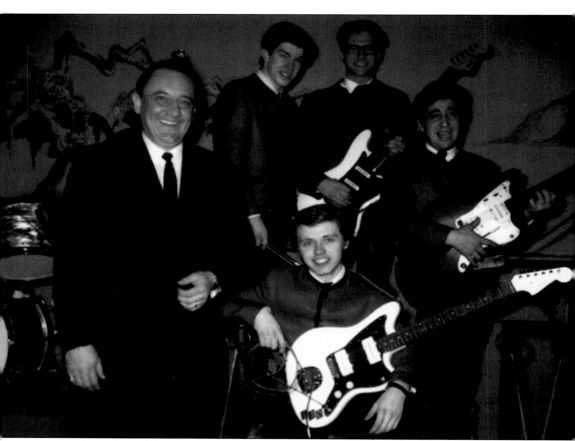

Timing is everything, and the coming of The Beatles within weeks of the debut of a hot new television music/dance show could not have been more finely tuned. And how fitting that WHK's "Emperor Joe" Mayer would be one of several deejays who hosted *The Big 5 Show*. Mayer was, of course, a big Beatles fan, but he was also a staunch supporter of local groups like this one, The Grasshoppers, known for their leaping about on stage as they played. The group made regular appearances on the show that became *Upbeat* in its second season, and had two regional hits, "Mod Socks," and "Pink Champagne (and Red Roses)." The latter was written by the bright, smiling boy in front, Benjamin Orzechowski, who later, as Ben Orr, cofounded The Cars with Ric Ocasek. (Diane Akins collection.)

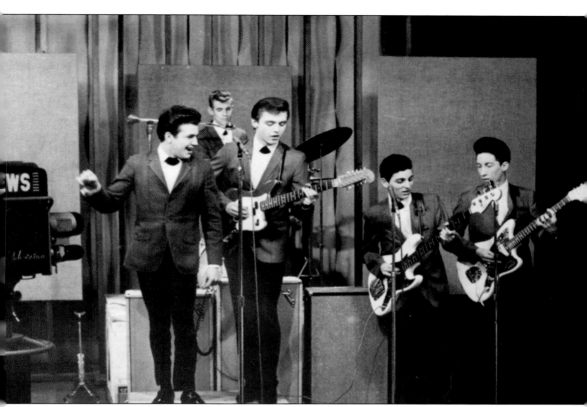

In 1966, The Grasshoppers became Mixed Emotions, but continued to perform on what was now the syndicated *Upbeat Show*. The opportunity to perform on a show that aired on television stations throughout the country gave Cleveland-area bands a real shot at national exposure. Thus, the Mixed Emotions with, from left to right, Jimmy Vince (lead vocals), Joey Kurelic (drums), Ben Orr (lead vocals/lead guitar), David Gardina (bass), and Chris Kamburoff (rhythm guitar), often got the best of gigs as opening band for popular 1960s acts, including Billy Jo Royal, Terry Knight and the Pack, and Paul Revere and The Raiders. (Photograph by George Shuba.)

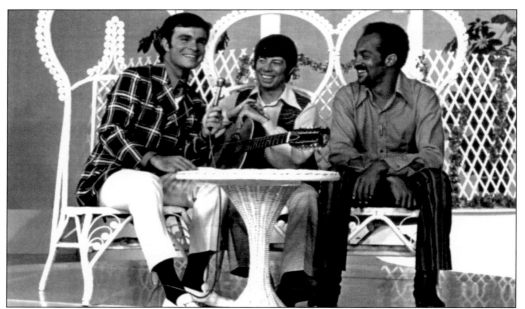

After *The Big 5 Show's* first season, its producer decided to get his own Dick Clark and hired Don Webster as host. The program name was then changed to the more hip *The Upbeat Show*. (Though "hip," when it came to these 1960s fashions, was subjective). Here, the handsome host chats it up with singer Bobby Goldsboro and WIXY deejay Billy Bass. (Photograph by George Shuba; David Spero collection.)

David Spero, son of producer Herman, began working on the show at 13 as a cue card holder. This exposure helped Spero launch a career as deejay and music manager (Michael Stanley Band, Joe Vitale, Joe Walsh, Harry Nilsson, Eric Carmen, actor/musician Billy Bob Thornton, and Cat Stevens). He also served as vice president of education and public programming at the Rock and Roll Hall of Fame and Museum. (David Spero collection.)

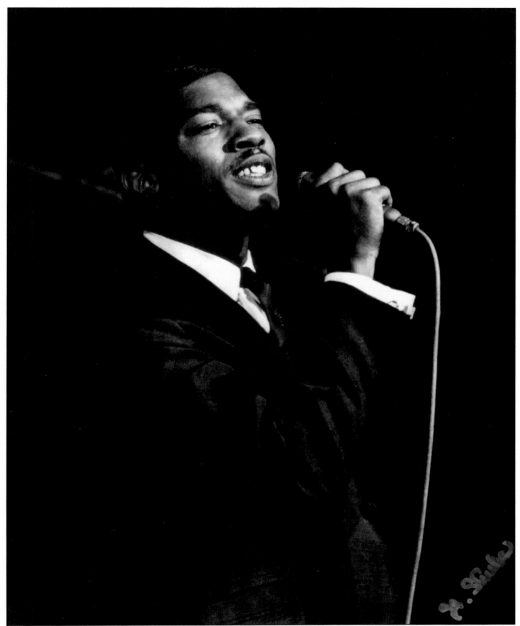

Edwin Starr grew up in Cleveland, where he formed a doo-wop group, The Future Tones, before moving to Detroit in the early 1960s, and was picked up by Motown Records. His 1968 song "Twenty-five Miles" reached No. 6 on U.S. charts the following year. Starr's biggest hit, however, would come in 1970 when he released a song originally recorded by The Temptations. That song, "War," was so controversial in the heat of Vietnam that the hugely popular Temptations was leery about releasing it as a 45 single, afraid it might damage their career. Starr then recorded it and it became a No. 1 hit on *Billboard*, earning this former Clevelander a Grammy Award nomination for Best Male Rhythm and Blues Vocal Performance. Here, he sings his hit songs on *The Upbeat Show*. (Photography by George Shuba.)

If the teens were not listening to their favorite deejays on the radio, watching *Bandstand* on television, or hanging out at their local record store, they were spinning records in their basements, or—unknown to parents—listening to the music on their transistor radios under the covers at night. And even in the comfort of their homes, young girls like 16-year-old Camille Mintz, seen here, dressed appropriately, complete with mini-dress and go-go boots. (Cleveland Press collection.)

Record stores were hip places to hang out with friends, and so were record conventions, where music fans could run into local celebrities, such as this Public Hall event where Michael Stanley and company were promoting the group's *Stagepass* album. Peaches Records and Tapes manager Larry Bole (second from left) was among many who were avid supporters of local music. (Courtesy of Larry Bole.)

Dan Gray, here with longtime friend Brad Bell, helped owner Shelly Tirk make his stores into hip hangouts. In turn, Tirk gave Gray a corner in his Music Grotto store for a T-shirt iron-on business. Screwy Louie's T-Shirt Shop did so well, Gray started his own company, Daffy Dan's T-Shirt Printing, with iconic logo, and catchy slogan, "If it doesn't have a D-D on the sleeve, it's just underwear." (Brad Bell collection.)

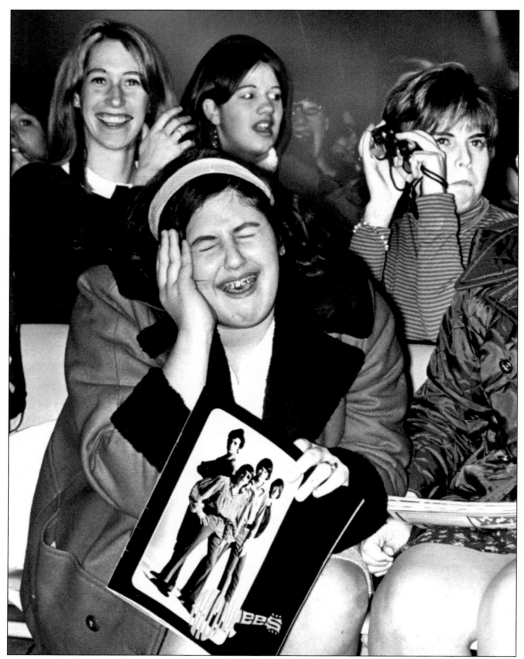

Rock and roll was definitely a new era in pop culture, but one thing remained consistent. Just as their parents swooned over the likes of Frank Sinatra, Dean Martin, and Johnny Mathis, this new baby boomer generation had its own musical idols. Girls not only screamed—and even fainted—over the Beatles, they also worshipped other pop groups like the Monkees, who performed here at Public Hall in 1967. And so, having an opportunity to see their music heroes play their hit songs live was sometimes just more than a young girl could bear. (Cleveland Press collection.)

Three

RADIO WARS

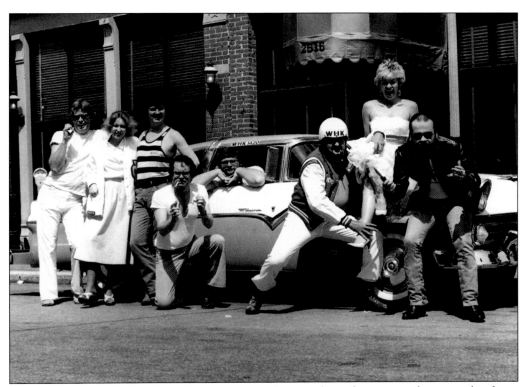

Cars and girls were integral to pop culture in these early rock years, and so was the fierce competition among radio stations where jocks took their battles seriously. In advertisements to demonstrate their energy and "drive," WHK employees always looked ready for a rumble. Posing here are, from left to right, Gary Dee, Cynthia Smith, Terry Stevens, Ray Hoffman, J. R. Nelson, Doc Lemon, Carolyn Carr, and Jim Crocker. (Photograph by George Shuba.)

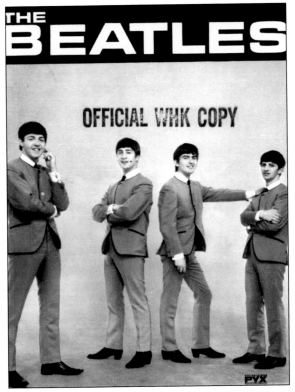

THE BEATLES

OFFICIAL WHK COPY

PVX

Beatlemania was everywhere—from bubble gum packs featuring "Collectable Beatles Cards!" to life-sized posters, magazines, and other literature. This pamphlet (the call letters stamped across the cover reminded fans who first "brought The Beatles to Cleveland") was filled with captivating photographs, behind-the-scenes information, and lively stories about the "Fab Four." WHK kept their promotional edge by boasting "color radio": their wide range of music, and colorful "Good Guys." Merchandising became big business. T-shirts and sweatshirts promised wearers they could be as cool as their favorite deejays. The station had nothing to do, however, with the most prominent promotion. In 1967, WHK's call letters showed up on the cover of the Beatles' album, *Sgt. Pepper's Lonely Hearts Club Band* (a doll wearing a sweater that reads, "WHK Good Guys Welcomes The Rolling Stones"). (Above, Jim Davison collection; below Brad Bell collection.)

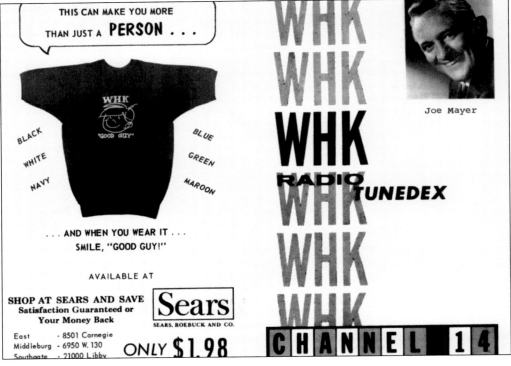

THIS CAN MAKE YOU MORE THAN JUST A **PERSON** . . .

WHK "GOOD GUY"

BLACK
WHITE
NAVY
BLUE
GREEN
MAROON

. . . AND WHEN YOU WEAR IT . . .
SMILE, "GOOD GUY!"

AVAILABLE AT

SHOP AT SEARS AND SAVE
Satisfaction Guaranteed or
Your Money Back

Sears
SEARS, ROEBUCK AND CO.

East - 8501 Carnegie
Middleburg - 6950 W. 130
Southgate - 21000 Libby

ONLY **$1.98**

WHK
WHK
WHK

Joe Mayer

WHK
RADIO TUNEDEX
WHK

WHK

WHK

CHANNEL 14

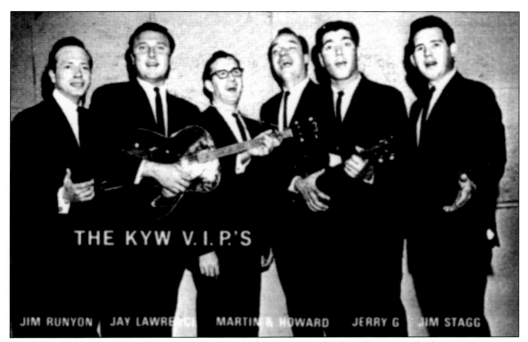

THE KYW V. I. P.'S

JIM RUNYON JAY LAWRENCE MARTIN & HOWARD JERRY G JIM STAGG

WHK had lots of competition, which made for great radio choices. Fortunately for KYW, it was a 50,000-watt clear-channel station, as opposed to WHK's 5,000 watts. They also had those VIPs, such as Martin and Howard, Jay Lawrence, and Jerry G. (whose prime-time shift 6:00 to 10:00 p.m. consistently won the all-important ratings wars). This helped secure KYW as the city's No. 1 Top 40 station in 1965. (Brad Bell Collection.)

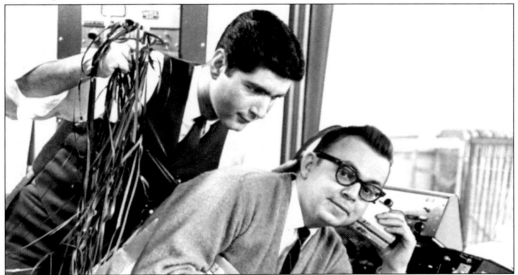

KYW deejays Jerry G. and Phil Harper ham it up here for a *Cleveland Press* article in 1965. (In those days, music came by way of records: 45-singles and 78-LPs, and also reel-to-reel tapes.) Whereas the mainstream media ignored what was happening on the rock and roll scene pre-Beatles, now the music makers, and music spinners, were bone fide celebrities, receiving regular mentions in newspapers and magazines. (Cleveland Press collection.)

What better way to get listeners' attention than producing a record the deejays recorded themselves. The B-side to "Cleveland Love Song" managed several promotional feats: Hype up the station's VIPs, hail the city itself, then make much to-do over giving away this special record to the "winer" of a contest, though it obviously did not guarantee that all employees knew how to spell. (Jim Davison collection.)

Funny thing happen to you on the way to school? At school? At home? At work? If it's nutty enough, tell us about it. You'll win a box of mixed nuts.

JIM GALLANT
loves
FIGHT FOR YOUR FAVORITES

Jim Gallant likes phone calls. It's kind of lonely on the all-night show. That's why he began "Fight for Your Favorites" on his EARLY all-night show on Saturdays. Each Saturday between 10 p. m. and Midnight, listeners are asked to choose between two groups or two individual recording stars. There are a lot of sore losers in Jim's audience. But gallant Jim forges on. He knows there are more happy winners

While deejays battled against competitors, they also fought for their listeners by making sure they had the hits fans wanted to hear, plus give them a chance to vote for their favorite songs. These promotional cards were available free at area record stores. One side featured the record charts, the other, facts about the deejays and their air shifts. (Brad Bell collection.)

RADIO 1100

Memorable Moments of 1965:

JERRY G remembers THE BEATLES

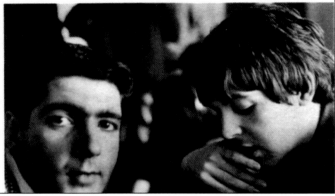

The most exciting, memorable — and often frantic — moments of Jerry G's eventful year were spent last August in the company of four musically-inclined gentlemen named, John, Paul, George and Ringo. It was late in July when Jerry received word he had been appointed an official correspondent for the Beatles' 1965 American Tour, the only Cleveland radio personality so honored. From the moment "the guys with the hair in their eyes" made their tumultuous arrival in New York until the time of their final departure from California 17 days later, Jerry lived, traveled, ate, swam, and shared experiences with the most successful foursome in modern entertainment history. His stories on their activities were heard

Jerry G (Ghan) was one of the hottest deejays in Cleveland, thanks to his close association with the most renowned pop band in the world. Yet even this VIP could get star struck. While touring with the Fab Four (who returned for their second Cleveland appearance in August 1966), Jerry G acquired hours of one-on-one interviews, which he edited down for a one-hour special for his radio program. (Brad Bell collection.)

RADIO 1100

ALL ABOARD FOR BEATLE LAND

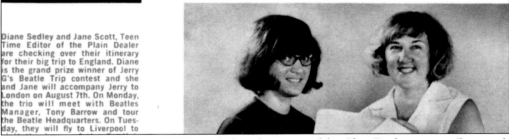

Diane Sedley and Jane Scott, Teen Time Editor of the Plain Dealer are checking over their itinerary for their big trip to England. Diane is the grand prize winner of Jerry G's Beatle Trip contest and she and Jane will accompany Jerry to London on August 7th. On Monday, the trio will meet with Beatles Manager, Tony Barrow and tour the Beatle Headquarters. On Tuesday, they will fly to Liverpool to

The Beatles invasion impacted many, including the career of this *Plain Dealer* reporter (here with a lucky contest winner). Jane Scott (right) began working for the *Plain Dealer* in 1952, but it was the 1966 Beatles concert that kick-started her career as the first rock reporter in Cleveland—and possibly the country. Although in her 40s, "Jammin' Jane" felt right at home interviewing 20-something musicians like John, Paul, George, and Ringo. (Brad Bell collection.)

43

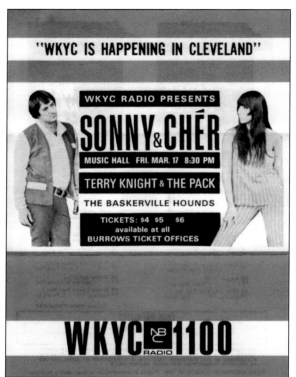

"WKYC IS HAPPENING IN CLEVELAND"

WKYC RADIO PRESENTS

SONNY & CHÉR

MUSIC HALL FRI. MAR. 17 8:30 PM

TERRY KNIGHT & THE PACK

THE BASKERVILLE HOUNDS

TICKETS: $4 $5 $6
available at all
BURROWS TICKET OFFICES

WKYC NBC RADIO 1100

WKYC sponsored many of the rock groups of the day and Sonny and Cher ("I Got You Babe") was the hottest duo in pop history in the 1960s. In 1965, they performed at one of the city's favorite concert venues, Music Hall, and tickets (notice the price) sold fast. Local band The Baskerville Hounds, whose records included "Debbie" and "Space Rock," (the latter was the theme song for local television show *Ghoulardi*) opened for them here. (Brad Bell collection.)

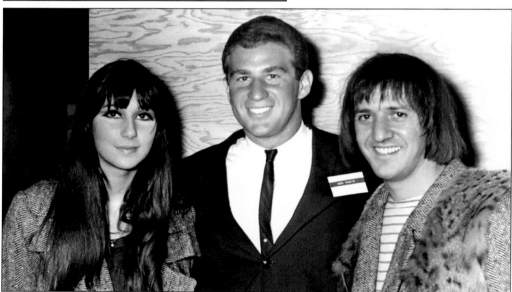

Sonny and Cher also performed at the 1965 WHK Appreciation Day (these outdoor events acknowledged appreciation to loyal listeners). Teen intern Walt Tiburski began at WHK and one of his first assignments was to escort pop idols to this rocking event, held at Geauga Lake Park. Tiburski would have a lucrative career in radio as vice president for WMMS-FM through its most prominent years, and then as vice president and general manager at WNCX. (Walt Tiburski collection.)

THE TOP 11

1. **Time Won't Let Me** (1)
 Outsiders
2. **Listen People** (3)
 Herman's Hermits
3. **Ballad Of Green Berets**
 (−) SSgt. Barry Sadler

5. **Lightnin' Strikes** (2)
 Lou Christie
5. **19th Nervous Breakdown**
 (16) Rolling Stones
6. **California Dreamin'** (−)
 Mamas & Papas
7. **Nowhere Man** (−)
 Beatles

8. **These Boots Are Made For Walkin'** (7)
 Nancy Sinatra
9. **Love Makes The World Go Round** (−) Deon Jac
10. **You Baby** (6)
 Turtles
11. **I See The Light** (8)
 5 Americans

12. **Woman** (18)
 Peter & Gordon
13. **Homeward Bound** (20)
 Simon & Garfunkel
14. **At The Scene** (−)
 Dave Clark 5
15. **Batman's Theme** (12)
 Marketts
16. **I Fought The Law** (19)
 Bobby Fuller 4
17. **Secret Agent Man** (−)
 Ventures
18. **When Likin' Turns To Lovin'** (−) Ronnie Dove
19. **Working My Way Back To You** (11) 4 Seasons
20. **Uptight** (13)
 Stevie Wonder
21. **Time** (−)
 Pozo Seco Singers
22. **What Now My Love** (21)
 Sonny & Cher
23. **From A Distance** (22)
 P. F. Sloan

24. **Dedication Song** (−)
 Freddy Cannon
25. **Batman** (−)
 Jan & Dean
26. **Inside-Lookin' Out** (−)
 Animals
27. **Somewhere There's A Someone** (−)
 Dean Martin
28. **It Won't Be Wrong** (−)
 Bryds
29. **Love Is All We Need** (−)
 Mel Carter
30. **Don't Wait Up For Me, Mama** (−)
 Billy Joe Royal
31. **I Love You More Than Yesterday** (−)
 Carl Maduri
32. **It's Too Late** (−)
 Bobby Goldsboro
33. **Bang, Bang, I Shot My Baby Down** (−) Cher

34. **Sure Gonna Miss Her** (−)
 Gary Lewis & The Playboys
35. **Baby Scratch My Back**
 (−) Slim Harp
36. **Tears** (−)
 Bobby Vinton
37. **The Cheater** (−)
 Bob Kuban
38. **The One On The Right On The Left** (−)
 Johnny Cash
39. **Flowers On The Wall** (−)
 Chet Baker
40. **Twelfth Of Never** (−)
 Slim Whitman
41. **Promise Her Anything** (−) Tom Jones
42. **You Bring Me Down** (−)
 Royalettes
43. **The Rains Came** (−)
 Sir Douglas
44. **Walkin' My Cat Named Dog** (−) Norma Tane

VERY IMPORTANT PREMIERES

The Love You Save
Joe Tex

Look For The Rainbow
Linda Ro

Gloria
Shadows of Knight

A Public Execution
Mou

THE WKYC RADIO "SOUND 11 SURVEY" REPRESENTS THE JUDGMENT OF WKYC
RECORD SELECTION COMMITTEE AS TO THE RELATIVE POPULARITY OF CURRENT
RECORDINGS IN THE CLEVELAND AREA AND IS CONDITIONED BY SUCH FACTO
AS INDUSTRY TABULATIONS AND LOCAL RECORD SALES

Until the late 1960s, a deejay's playlist included a wide span of music genres—from rock to country music. So it was not unusual to see such diverse artists as The Rolling Stones, Stevie Wonder, Dean Martin, and Slim Whitman all on the same music survey chart. So it was a particularly proud Cleveland moment when one of its own made the coveted number one spot in the all-important WKYC sound survey. Tom King and The Starfires had only recently changed their name to The Outsiders when their song "Time Won't Let Me" became a big hit. The following year, another Cleveland band, The Choir, would hit this same No. 1 position with their record *It's Cold Outside* on April 28, 1967. (Brad Bell collection.)

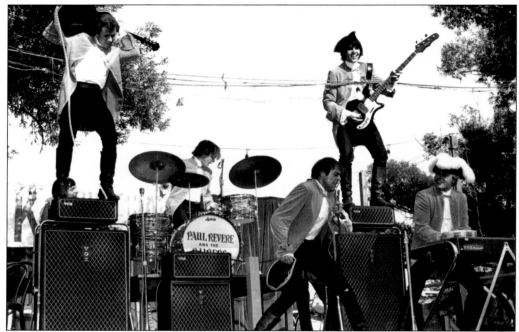

Paul Revere and the Raiders were the darlings of early pop rock and a Cleveland favorite. It was not just the songs that made the group so popular with their fans, but also their enthusiastic live shows. Here, playing at one of the WHK Appreciation Days, lead singer Mark Lindsay and company demonstrate how wholly entertaining they could be. (Photograph by George Shuba.)

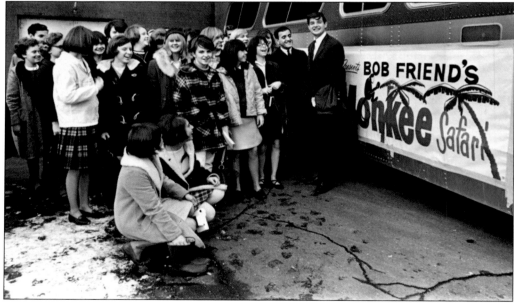

WHK deejay Bob Friend took his name to heart when he played chaperone to 21 young Monkees fans. The contest winners and their guests boarded a bus bound for Pittsburgh to attend the group's concert there in 1966. *Cleveland Press* pop culture writer Bruno Bornino, next to him, joins in the fun. (Cleveland Press collection.)

WOULD YOU BELIEVE A PONTIAC GTO?

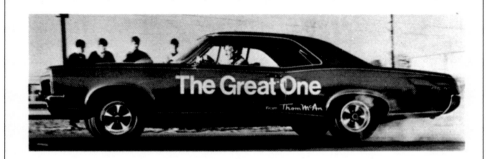

Better yet... would you believe a Pontiac GTO in your driveway? The Great One, Jim La Barbara is going to give away "The Great One," a 1967 Pontiac GTO. This is not an ordinary GTO... it is a Thom McAn GTO, of which there are only 20 in the entire United States... and you may very well be the lucky winner. To enter, simply drop by your neighborhood Thom McAn Shoe store, or WKYC, and pick up an entry blank... and while you are there... register for the great prizes being given away nightly on the Jim La Barbara Show. For additional information and MUCH MORE MUSIC, listen to WKYC Radio.

In the 1960s, car radios, drive-in movies, and restaurants with "car hops" were what made teen life so great. WKYC deejay Jim LaBarbara obviously wanted this grand prize for himself when his station offered this brand new GTO to a lucky winner in November 1966. This was when the Beach Boys song "Good Vibrations" was in the No. 1 spot on the station's Sound Eleven Survey. But those good vibrations did not last for LaBarbara, who was let go along with other WKYC deejays in January 1968 (due to new management). However, the popular radio man was snapped up by what would soon be the city's most popular radio station, WIXY-1260. (Brad Bell collection.)

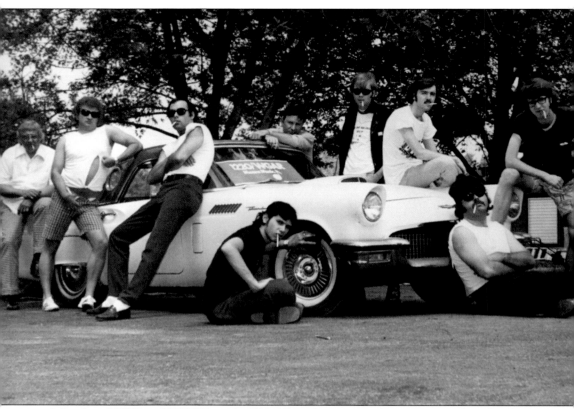

Like their WHK and WKYC rivals, WGAR jocks got into the promotional act by displaying their own wild side next to a 1957 Thunderbird in 1973. The big and bad deejays here are, from left to right, (first row) former WHK Good Guy Joe Mayer, John Lanigan, and Loren Owens, with Geoff Fox by the wheel; (second row) Chick Watkins, Brian Beirne, Jim Buchanan, Buddy Henderson, and Chuck Collier, seated against the grill. (This promotional advertisement was, of course, in the days before smoking was banned both on television and other advertisements.) Radio wars revved up fast and furious in 1965 when WIXY came on board with promotions that went beyond the typical cars and jocks angle. (Photograph by George Shuba.)

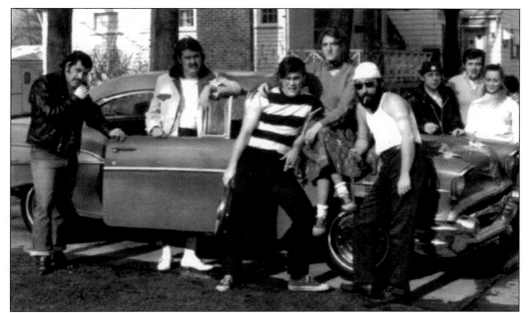

Of course, WIXY got into the car posing act, too. From left to right are Bob Shannon, Terry Stevens, Jeff McKee, an unidentified girl from the office crew, Mike Reineri, Chuck Dunaway (in back), Gary Drake, and another unidentified office worker. WIXY was famous for its madcap contests, ongoing concerts, not-to-be-forgotten radio skits like "Chicken Man, the White-Winged Weekend Warrior" and call letters ready-made for a fun, rhythmic jingle—"WIXY 1260 – *Super Radio!*" (Chuck Dunaway collection.)

WIXY always took things one step further than its competitors, and this was the kind of car more to deejay Chuck Dunaway's liking. "[It] was an experimental Oldsmobile Cutlass supplied by Detroit and souped up by Lakewood Industries who specialized in safety products for race cars," Dunaway explains. "We won a few trophies in the Amateur division at Thompson Drag Raceway." (Chuck Dunaway collection.)

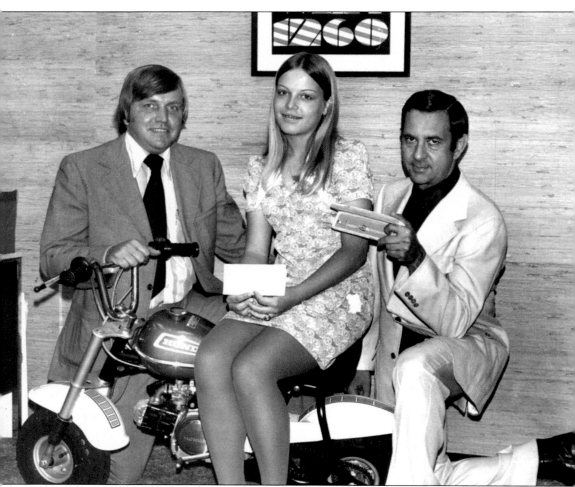

WIXY always made headlines with big promotions and impressive giveaways—continually upping the ante against the competitors. The big winner here, a 14-year-old Brooklyn High School student, sits on her newly acquired Honda mini-bike while holding an "interest" check for one day on $1 million. Next to her is the "Diamond Man," jewelry store owner Larry Robinson, who gifts her with a diamond wrist watch. In addition, the teenager won a party for 1,000 friends with music by local band Circus at the teen club The Corral. An 11-by-14-inch portrait completed her big win. (Cleveland Press collection.)

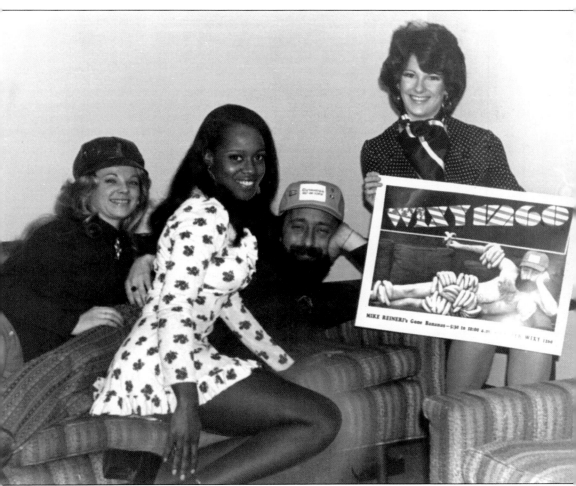

In 1972, actor Burt Reynolds made beefcake history by posing for *Cosmopolitan* magazine. The controversial photo spread was one of the most talked about events that year. So naturally, WIXY had to put its own spin on it. Morning-drive air personality Mike Reineri (surrounded here by local beauties competing for the Miss Universe pageant), decided to do a spoof on the infamous centerfold by posing for his own—while at the same time advertising his radio show. This was just another of the many off-the-wall promotions the station was famous for. (Cleveland Press collection.)

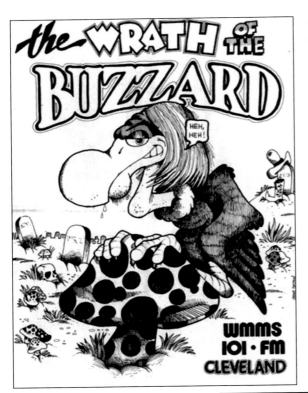

Then came FM radio, and WMMS, with young charismatic deejays, a savvy marketing crew, and this mighty mascot, "The Buzzard." The predatory bird with the snarly grin would fast become a radio icon in its own right. (Illustration by David Helton; courtesy of John Gorman.)

When original Buzzard artist David Helton left, former *Scene* illustrator and photographer Brian Chalmers (who had worked alongside Helton for years) became the man behind the bird. Under Chalmers's pen, the Buzzard continued to be present wherever the station promoted: newspapers, magazines, posters, bulletin boards, television commercials, and of course, bumper stickers and T-shirts. The mascot and its calling card became a symbol of radio advertisement at its best. (Design and illustration by Brian Chalmers.)

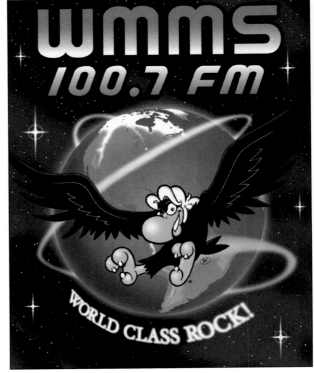

Four

EARLY ROCKERS

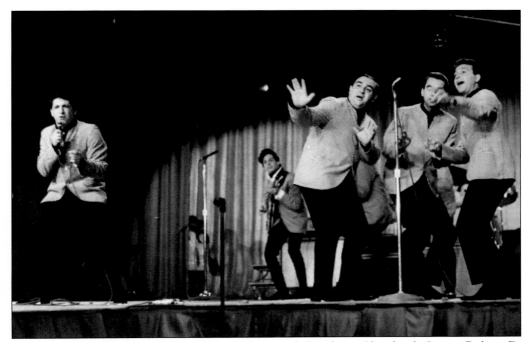

Bocky and the Visions was one of the earliest rock bands in Cleveland. Singer Robert Di Pasquale, also known as Bocky, had good looks, powerful vocal range, and entertaining stage presence, attracting swarms of teenage girls wherever they performed. Here the group opened for The Rolling Stones at the Cleveland Convention Center. Their records "Spirit of '64" and "I'm Not Worth It" were local hits. (Photograph by George Shuba.)

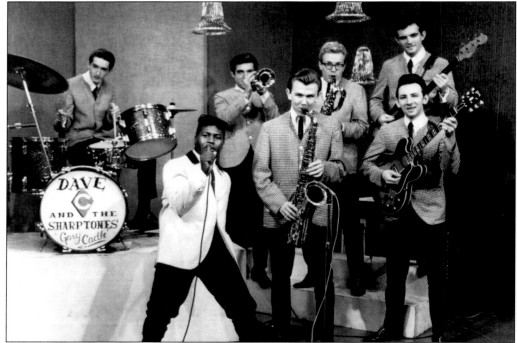

Dave C. and The Sharptones formed in 1956 with drummer Dave Cox, who became the band's frontman after seeing James Brown at the Cleveland Arena. The group enjoyed some local hits, "The Skateland Bounce," "Diane," and "Black Pepper;" were regulars on *The Upbeat Show*, seen here; and opened for dozens of national acts. (Photograph by George Shuba.)

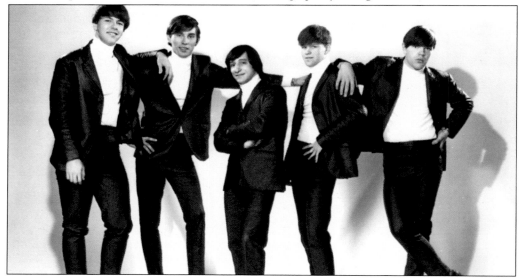

The Tulu Babies, formerly the Dantes, with lead singer Dante Rossi (middle) were managed for a time by WHK deejay Ron Brittain. The group recorded "The Hurtin' Kind," which did well regionally. The producer of that record, Jim Testa, took over as manager in 1965 and changed their name to The Baskerville Hounds, after which they hit the *Billboard* charts in 1969 with "Hold Me." (Courtesy of Dante Rossi.)

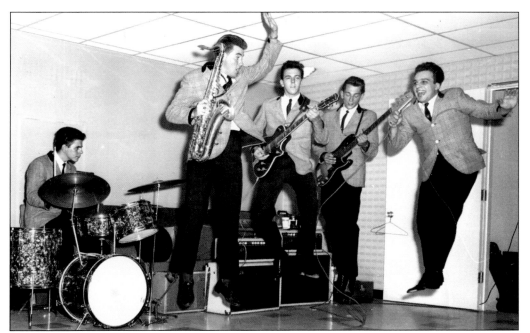

Joey and the Continentals formed in 1961 with Gene Marotta (drums), Dennis Slifco (sax), Ray Miller (guitar), Don Evans (bass guitar), and Joey Porrello (vocals). The group was perhaps jumping for joy on securing a gig as one of the house bands on the *Upbeat Show*, for which they changed their name to the cooler moniker The GTOs. Their records included "Linda," "No One Can Make My Sunshine Smile," and "She Rides with Me." (Courtesy of Ray Miller.)

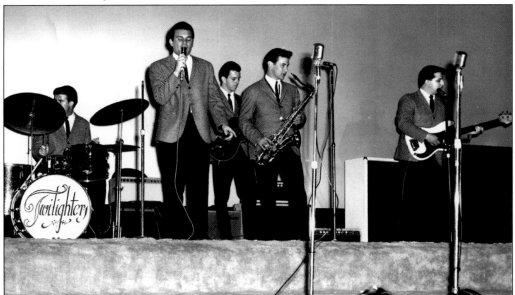

The Twilighters, Randy Brown (drums), Tony Liotta (vocals), Ray Miller (guitar), Dennis Samsa (sax), and Steve Popovich (bass guitar, far right) were local favorites, and their record "Be Faithful" enjoyed regular spins on local radio stations. Popovich would go on to an impressive behind-the-scenes music career. (Courtesy of Ray Miller.)

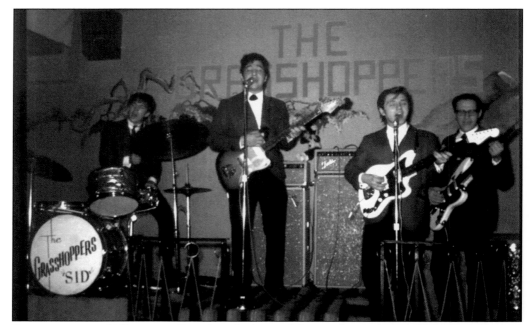

Seventeen-year-old Benjamin Orzechowski (second from right, top) joined The Grasshoppers in 1964, replacing the group's rhythm guitarist and founder Dante Rossi. The Grasshoppers soon turned into Mixed Emotions, then the Colours before disbanding in 1966. But Orzechowski, who shortened his last name to Orr, would become a full-fledged rock star as bass player and cofounder of The Cars in 1976 with Ric Ocasek, who also has Cleveland roots. That group hit a high note with "My Best-Friend's Girlfriend," "Just What I Needed," and "Drive," among others. Although Orr (middle, bottom) would never return to his hometown, he maintained close ties with his family and childhood friends until his untimely death from pancreatic cancer in October of 2000. (Courtesy of Diane Akins.)

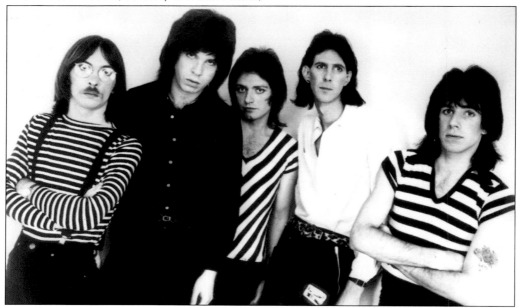

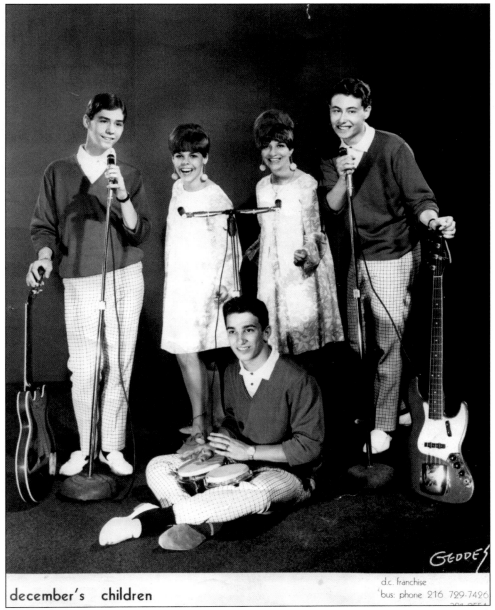

december's children

d.c. franchise
bus: phone 216 729-7426

December's Children, seen here in 1967, was known for its Motown repertoire, songs that featured four-part vocal harmony. This formation, with, from left to right, Craig Balzer, Janet Belpulsi, Alice Popovich, Bill Petti, and Ron Papaleo (front), played teen dance venues as well as adult night spots such as The Plato, Otto's Grotto, Hires Lounge, and The Inn Spot. They were also the first band to perform at the Cleveland Agora when it opened at its most famous location near Cleveland State University. In 1969, Belpulsi left the group, replaced by Bruce Balzer (Craig's brother). In 1970, jazz guitarist Bill D'Arango (who used to perform with Dizzie Gillespie in the 1940s) became the group's manager and got them signed to Mainstream Records. The group disbanded in 1971 after their album failed to launch and the record label dropped them. An all-too-common scenario in music. (Courtesy of Ron Papaleo.)

It has never been proven whether this band's name helped or hurt it. But their slogan, "Gang Green: For the Spread of Infectious Music," was catchy. Members included, from left to right, John Manring (bass guitar), Neil Slobin (vocals), Mike Gutin (keyboard), Alan Greenblatt (ne Greene, guitar), and Bob Miller (drums). The group's repertoire reflected its 1966 era with Top 40 pop/rock cover songs. Young bands played wherever they could get a gig, which meant a number of "shot-and-beer" bars. While some were forgettable, one stands out in Alan Greene's memory. "Between sets at the Yankee Bar, this heavy-set woman, Queenie, would come out dressed in a Harem costume carrying an Indian-style basket with this rubber snake in it which she'd entice to come out by dancing!" he recalls. Greene's gifted guitar playing has indeed become infectious through four decades in Cleveland's music scene. (Courtesy of Alan Greene.)

THE OUTSIDERS PACK 'EM IN

THANKS GANG...for making our VIP DAY at Cedar Point an all-out success. Just for the record, it was the biggest opening day in the history of the park. The day began with a caravan from the Cleveland Stadium parking lot led by Harry Martin in the VIP Car. At 11:15 a.m. the caravan set out for Cedar Point, complete with police escort. Over 40,000 people were on hand to watch Jerry G on remote in the afternoon and a record-breaking 2,100 attended the all-star VIP Show in the evening. The show featured all the WKYC VIP's... plus, the GTO's...Mickey and the Cleancuts and the Outsiders. If

Tom King and the Starfires's sound was a popular blend of British and Motown. Their horn-driven instrumental "Stronger Than Dirt" became the theme song to the late-night television show *Ghoulardi*. In 1965, King brought in young Sonny Geraci to sing vocals and changed the group's name to The Outsiders. Here the popular group performs at Cedar Point Amusement Park. (Brad Bell collection.)

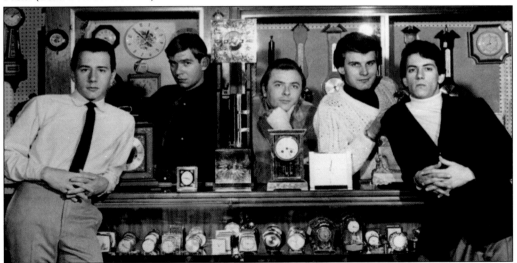

The Outsiders pose here amid the clocks that now dominated their lives. Their single, "Time Won't Let Me," rose quickly up *Billboard* charts in the spring of 1966. Time only allowed for promotional tours, album recordings, and publicity photographs. More hits came fast: "Girl in Love," "Respectable," and "Help Me Girl." The group disbanded in 1968, but singer Sonny Geraci (far right) found additional success with Climax, which recorded the No. 1 song "Precious and Few." (Photograph by George Shuba.)

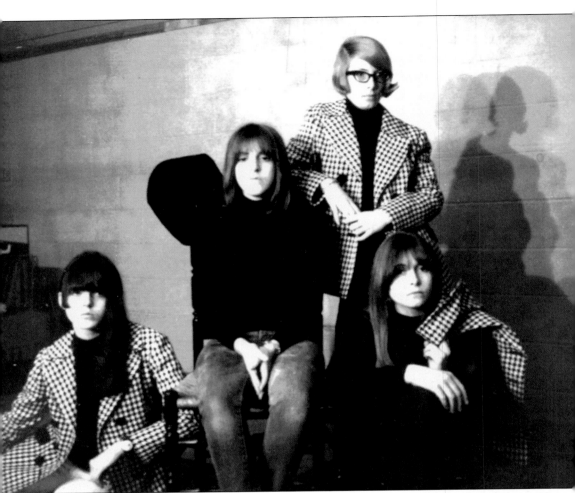

But the music scene was not limited to males. The Poor Girls (inspired by the then-fashionable Poor Boy sweaters) proved that girls could rock, too, when these high school students formed in 1965. The quartet included, from left to right, Pam Johnson, Debbie Smith, Esta Kerr, and Susan Schmidt. They played many of the popular songs of the day—and played them well—including impressive renditions of songs by the Beatles, The Supremes, and even Traffic. Because they were the first all-girl rock band in this area, the Poor Girls received a good amount of press, and respect from their male peers. Before breaking up in 1969, the group had opened for big-time groups such as Cream, Steppenwolf, the James Gang, and the biggest of them all, The Beatles (in 1966). (Courtesy of Debbie Smith.)

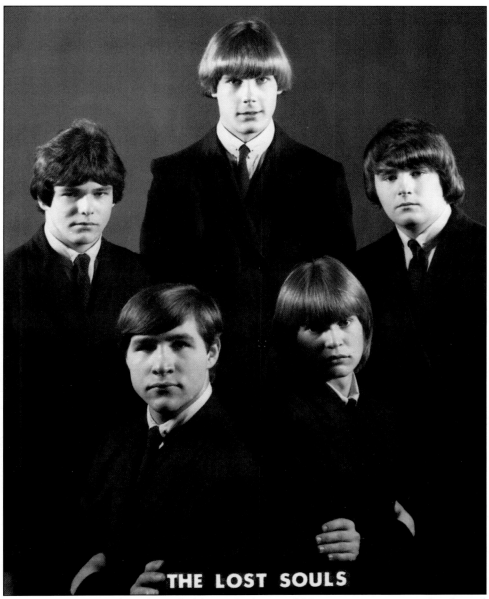

THE LOST SOULS

In the 1960s, groups often dressed alike and what could be more appropriate for these five Catholic schoolboys than respectable suits and ties? However, their "long" hair got in the way of academics when these members of The Lost Souls were suspended from St. Joseph High School and forced to "trim" their hair in order to graduate. Still, the band did not miss a beat, performing at "every Catholic parish on both sides of Cleveland." The group included, clockwise from left, Rich Schoenaur (sax and flute), Dennis Marek (guitar), Chuck McKinley (bass), Denny Carleton (bottom right), and Larry Tomczak (drums). Their finest hour came when they opened for the 1966 Beatles concert, despite it being the most frightening. "All these girls came after us screamin'," Carleton recalls. "We got mobbed and I was scared to death we were going to get crushed. 'Course now I look back and think, 'Wow, that was pretty neat!' " (Courtesy of Denny Carleton.)

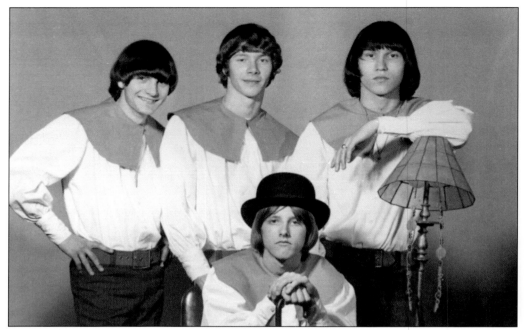

The Mods consisted of four restless Beatles-loving teenagers who practiced in garages and basements and even began writing their own songs. They became the Choir in 1966 with, from left to right, Jim Bonfanti (drums), Dave Smalley (guitar), Wally Bryson (guitar), and Jim "Snake" Skeen (bass). Their catchy tune, "It's Cold Outside," peaked on *Billboard* at No. 68. It remains one of the most identifiable records in Cleveland music. (Photograph by George Shuba.)

This was a proud moment for Choir guitarist Wally Bryson, to stand with members of his favorite rock band, The Who, in 1967. This backstage photograph brings together, from left to right, The Who's bass player John Entwistle, WHK's Walt Tiburski, The Who's frontman Roger Daltry, and Bryson. The unique wall in the background featured signatures from many who performed at Music Hall over the years. (Walt Tiburski collection.)

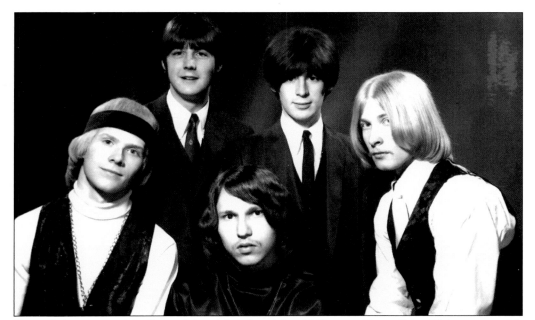

One of the most critically acclaimed bands of the 1960s was Cyrus Erie. This group, with (clockwise from top) Marty Murphy (guitar, who left shortly after it was formed), Eric Carmen (guitar/vocals/ keyboard), Mike McBride (drums), Wally Bryson (guitar), and Bob McBride (bass), released the single "Sparrow" on Epic Records in 1969, but its B-side "Get the Message" received the most airplay. (Pat Kosovich collection.)

The Quick boasted an impressive line-up with, from left to right, Dan Klawon (bass), Randy Klawon (guitar), Mike McBride (drums), and Eric Carmen (vocals/guitar/keyboard). Formed by Eric Carmen, after Cyrus Erie and before the Raspberries, the short-lived group managed to record a record, "Ain't Nothing Going to Stop Me Now," before disbanding. Although the song went nowhere, its title was prophetic for the ambitious Carmen. (Wally Gunn collection.)

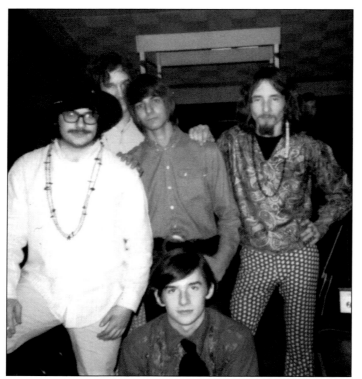

The original James Gang was a power quintet, and underwent several formations before the more recognized 1970s power trio with Joe Walsh. In 1967 the group was, from left to right, Fox (drums), Bill Jeric (guitar), Tom Kriss (bass), Glenn Schwartz (guitar), and Phil Giallombardo (keyboard). Their attire here typifies the 1960s: love beads, polka dot bell-bottoms, and the occasional silly hat. (Sixteen-year-old Giallombardo had to wear a wig for this photograph as his parents refused him to have "long" hair.) (Gene Schwartz collection.)

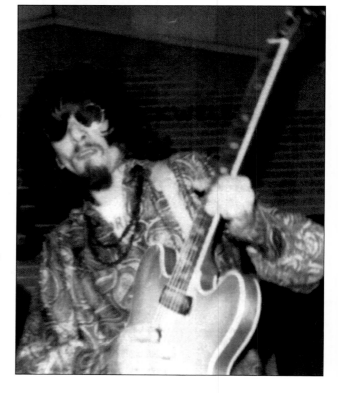

Virtuoso guitarist Glenn Schwartz gained local fame by playing the instrument with his teeth. In 1969, he formed the Los Angeles band Pacific Gas and Electric, which had a Top 20 hit, "Are You Ready?" He eventually returned to Cleveland and for 20 years, he and his brother Gene performed weekly at downtown's Hoopples River Bed Cafe. (Gene Schwartz collection.)

The Alarm Clocks, formed in Parma in 1965, was a quintessential rock and roll band. This popular trio included, from left to right, Bill Schwark (drums), Mike Pierce (vocals/bass), and Bruce Boehm (guitar). "We played covers of the day, a lot of Kinks, The Rolling Stones, and Yardbirds," Pierce recalls. They recorded original songs "Yeah" and "No Reason to Complain" and "were really beginning to excel," Pierce says, "but then Bruce was drafted and had to leave the band." So in 1967, The Alarm Clocks broke up, but in 2006 they returned (with lead guitarist Tom Fallon) for a much-heralded reunion concert with The Choir at Cleveland's Beachland Ballroom. (Courtesy of Tom Fallon.)

In 1968, guitarist Bill Constable read a book called *The Damnation of Adam Blessing* and decided it would be a great name for a band. So Bill became Adam, and another great Cleveland band was born. Members were, from left to right, Ray Benich (bass), Adam Blessing (also known as Bill Constable, guitar/lead vocals), Ken Constable (lead and supporting vocals), Jim Quinn (guitar/vocals), Bob Kalamasz (lead guitar/vocals), and Bill Schwark (also known as Billy Earle, drums). This hard rock quintet quickly secured a United Artists recording contract and released its self-titled debut album, which charted in *Billboard's* Top 10 thanks to the hit single "Morning Dew," then the 1970 hit "Back to the River." These were the band's glory days when they earned a reputation for unforgettable live performances. After constant touring, and a third album release, "Which is the Justice, Which is the Thief," the group disbanded in 1974. Still, says Quinn, "Being a part of that band remains the greatest experience in my life." (Courtesy of Ken Constable.)

Five

CLUBS AND VENUES THAT ROCKED

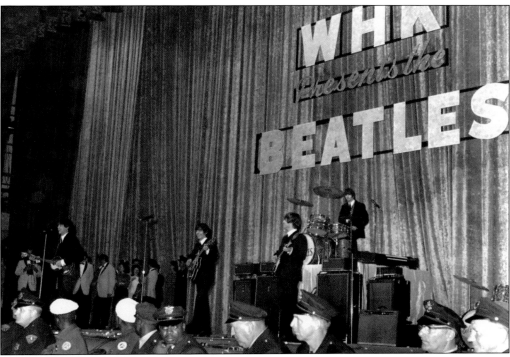

Cleveland's Public Auditorium was a big scene for concerts, with two divided stages/rooms in one building: Public Hall, with a 10,000-seat capacity, and the smaller, more intimate Music Hall that held 3,000. The Beatles' first Northeast Ohio concert took place here on September 15, 1964, before a wildly enthusiastic and loud audience. While the teenagers reveled in unabashed excitement, the local authorities, hired to keep the peace—and youngsters in line—seemed less than thrilled (Photograph by George Shuba.)

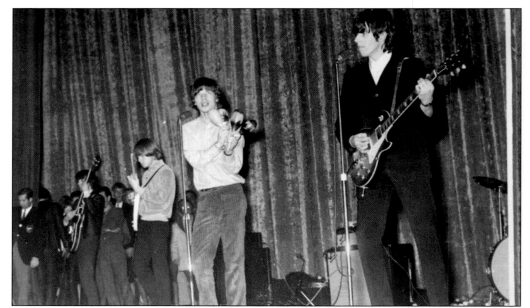

Parents and authorities soon became leery about the safety of rock concerts that brought packs of highly strung teenagers together in one venue. This Rolling Stones concert started out loud and rambunctious like any other, but this time, one excitable girl fell from the balcony, giving public officials the perfect excuse to ban all further rock acts from performing there, at least for a while. (Photograph by George Shuba.)

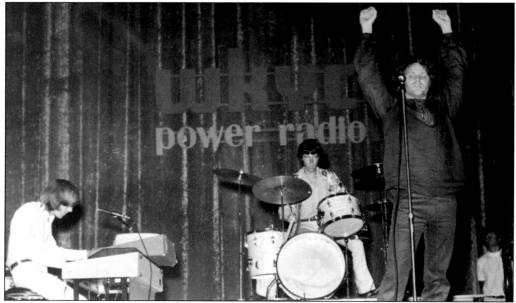

The ban on rockers at Public Hall was lifted in 1966, and musical acts returned with a vengeance. The Doors concert, seen here, almost did not happen since lead singer Jim Morrison was already causing problems for the band and their promoters, due to his extreme behavior. Just before this scheduled event, Morrison had been arrested on an obscenities charge in Miami. (Photograph by George Shuba.)

The Who made an unforgettable impression at this early Cleveland show. The group was becoming known for wild stage antics: smashing guitars, throwing drum sticks (and sometimes even the bass drum) into the audience, and blowing up expensive amps. Yet they were still an opening act here. After this performance, however, it is doubtful that headliners Herman's Hermits felt comfortable following such a tough act. (Photograph by George Shuba.)

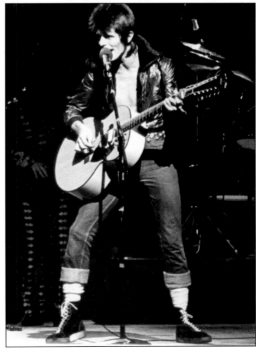

One of the most memorable concerts at this venue came in 1972 when a relatively unknown British singer named David Bowie made his debut U.S. appearance in Cleveland. A worthy entertainer, Bowie seduced his audience with his catchy pop songs and eccentric outfits. This one, a bit more subdued than the others, is an obvious tip of the hat to America's rock 'n' roll roots. (Photograph by Fred Toedtman.)

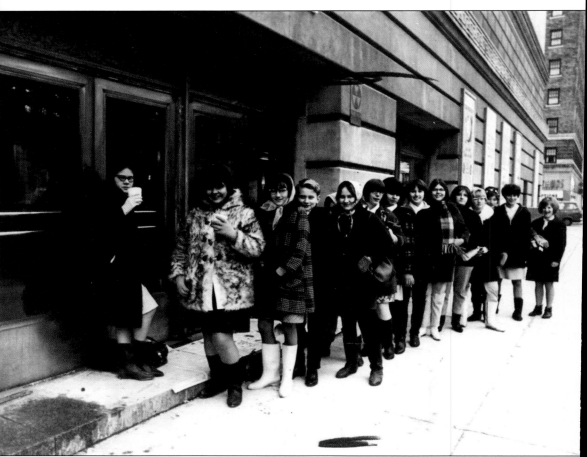

Part of the fun of going to a concert at the Public Hall was waiting outside to get in. These young Monkees fans (predominately female, as this 1967 photograph confirms) do not seem to mind the cold as they wait to get in to see their faves. The Monkees, an American rock/pop band, had a television show at the time, and like their British counterparts, The Beatles, caused every bit as much anticipation, excitement, and considerable mayhem. The next page attests this fact. (Cleveland Press collection.)

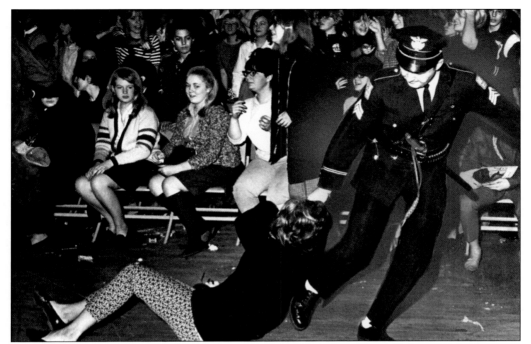

When the teenage girls got too excited, and their behavior went beyond the typical screaming and hollering, the men in blue would appear to tell the fan she could either settle down to enjoy the concert or she would have to leave the premises. This girl apparently did not like the options. (Cleveland Press collection.)

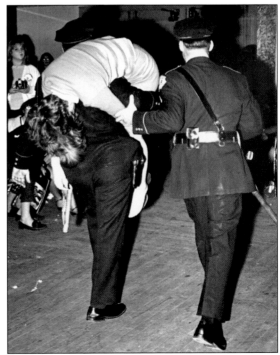

And sometimes a teen girl would get so overwhelmed at seeing her favorite pop star, she would simply faint and the men in blue, always at the ready, once again earned their pay. (Cleveland Press collection.)

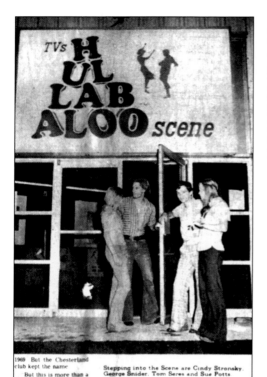

1969 But the Chesterland club kept the name

But this is more than a club. It's a Hullabaloo with

Stepping into the Scene are Cindy Stronsky, George Snider, Tom Seres and Sue Potts.

Advertised as "A Nightclub for YADS" (young adults), this club was named after the hit television dance show, and became the place to see live bands, mingle with other "Mods" (pre-hippies), and drink lots of Coca-Cola (alcohol was banned, of course). Teens came to see local bands as well as national ones, such as Jeff Beck, Rod Stewart, Todd Rundgren, and Alice Cooper. (*Plain Dealer* photograph by Robert E. Dorksen; Wally Gunn collection.)

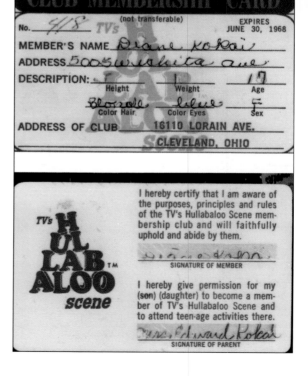

You were really part of the "In Crowd" if you were a Hullabaloo club member. "I don't recall if you got a discount or anything, it may have been just a status thing," says Diane Akins. "But my friend Benny Orr's band played there a lot, so he'd get us in for free." The clubs also boasted Hullabaloo dancers—cute girls in mini-skirts who danced on the side of the stage shaking up young boys' hearts. (Diane Akins collection.)

Both these young guitarists, Glenn Schwartz and Joe Walsh, were regular sights at the Hullabaloo clubs. Here is where they fine-tuned their guitar mastery. "Glenn was the biggest inspiration of my life," says veteran Cleveland guitarist Butch Armstrong. "First time I saw him [in the James Gang], he was up on stage pouring wet with sweat and saliva singing and attacking the guitar in every way and form. His enormous hands pulled and tugged the strings as if they were rubber bands, and he vibrated his notes with his fingers. He was incredible." Walsh, who would become Schwartz's replacement in that band, had his own distinct style as well, and gave early fans many "I remember him when" stories after he became an international rock star. (Gene Schwartz collection.)

Chesterland
HULLABALOO
A DANCE CLUB STRICTLY FOR YOUNG ADULTS (14-20)

April Fools Day Dance
Tuesday, April 1st - 8 to 11:30
The CYRUS ERIE

Fri., April 4 **The CYRUS ERIE**

Sat., " 5 **The SHEFFIELD RUSH**
(formerly The Munx)

Fri., " 11 **The CHOIR**

Sat., " 12 **The JAMES GANG**

WEST GEAUGA PLAZA
Mayfield Rd. & Rt. 306
8:00 to 11:30 p. m. Admission $1.50

This ad was no April Fools joke. This *c.* 1968 poster advertised some of the best rock bands in the Greater Cleveland area. While most area bands were competitive but friendly, there was some spirited tension between The Choir and Cyrus Erie after Eric Carmen "stole" coveted Choir member Wally Bryson to form his new band, Cyrus Erie. And while more bands were added to the roster each week, The James Gang would soon head toward national celebrity and no longer play teen clubs. (Wally Gunn collection.)

Named after one of the most popular area bands, astute business manager Don Ladanyi booked the best of local groups, knowing that was all it took to fill the place up each weekend. For it was not the club itself that attracted customers, it was the music. Teens would travel for miles just to see their favorite bands perform. Here Speed-O-Meter rocks at the west side teen club in 1972. The group consisted of, from left to right, Norm Isaac (guitar), Dave Nida (drums), and Randy Klawon (guitar), all of whom would go on to other bands and venues for years to come. Other hot teen venues included the Corral in Olmsted Falls, Utopia in Willoughby, and Stables in Painesville. (Norm Isaac collection.)

THE CYRUS ERIE WEST

38871 Center Ridge Rd.
North Ridgeville, Ohio
(40 Min. from Downtown Cleveland)

8:30 -12:00 Age 14-20

FRI. SEPT. 5	MOSES
SAT. SEPT. 6	CASE of E.T. HOOLEY
FRI. SEPT. 12	POE
SAT. SEPT. 13	QUICK
FRI. SEPT. 19	ADAM BLESSING
SAT. SEPT. 20	JAMES GANG
FRI. SEPT. 26	QUICK
SAT. SEPT. 27	SOUL PURPOSE

AFTER GAME ADMISSION 75¢ WITH TICKET STUB:

Admission $1.50

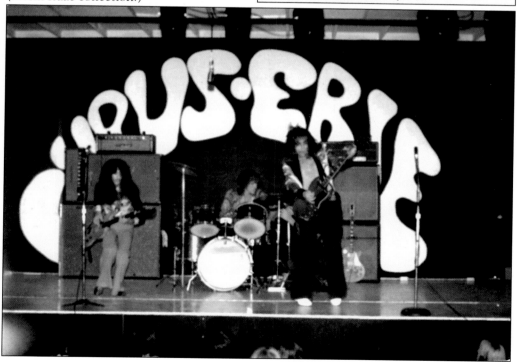

75

Once kids came of drinking age (18 back then), they abandoned the teen clubs for ones that offered more—like 3.2 beer. And the Agora Ballroom became the hottest. Owner Hank LoConti often booked little known acts just starting out, such as Bruce Springsteen, Bon Jovi, and Z.Z. Top before they broke nationally. (Pat Kosovich collection.)

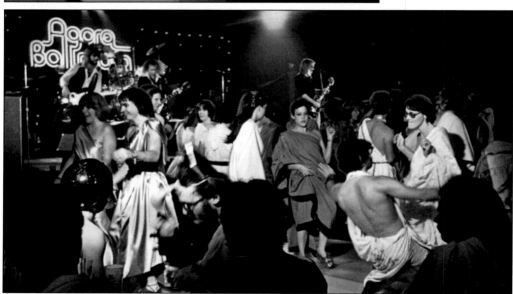

Among many theme parties that took place at the Agora was the toga party, inspired by the 1978 movie *Animal House*. While good times were taking place on the main floor, the basement was rocking too, often hosting not-ready-for-prime-time acts. Beginning as Viking's Den, then the Mistake, and finally the Pop Shop—this alternative underground had its fans too, until 1984, when the building burned down, breaking the hearts of rock lovers throughout the city. (Cleveland Press Collection.)

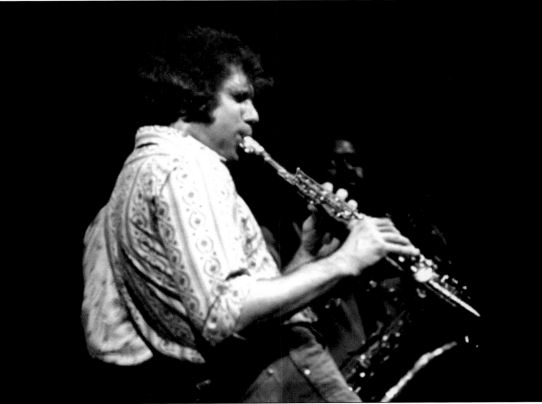

The Smiling Dog Saloon hosted an eclectic mix of music genres including folk, acoustic rock bands, and jazz artists. In 1971, jazz saxophonist Ernie Krivda became the frontman for its house band, Space. The now legendary Cleveland musician got his musical start here, sharing the stage with such jazz luminaries as Chick Corea, Elvin Jones, Cannonball Adderly, and Herbie Hancock. He would also record and tour with Quincy Jones and release a number of critically acclaimed albums. Krivda remains a fixture on the Cleveland music scene, fronting the renowned 19-piece Fat Tuesday Big Band. The Smiling Dog, meanwhile, would not last, but its reputation for featuring memorable acts fondly lives on for musicians and patrons alike. (Courtesy of Ernie Krivda.)

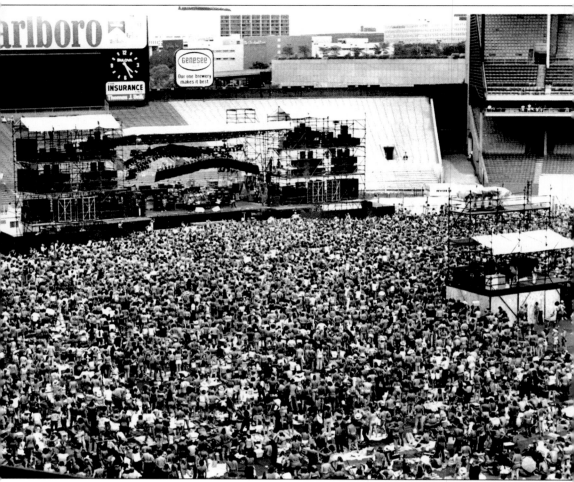

Beginning in 1974, concertgoers had a new, outdoor place to party—and party they did. The "World Series of Rock" concerts, held at the old Cleveland Stadium, were marathon events that attracted thousands to downtown Cleveland each summer. Promoters Jules and Mike Belkin brought in a roster of top rock acts that played continuously from noon till after sunset. The first stadium concert on June 23, 1974 (featuring Cleveland's adopted son Joe Walsh), drew 33,000 rock fans. As word got out the attendance rose, peaking at 86,000 for The Rolling Stones (according to the *Cleveland Press* afternoon edition) in 1978. (Cleveland Press collection.)

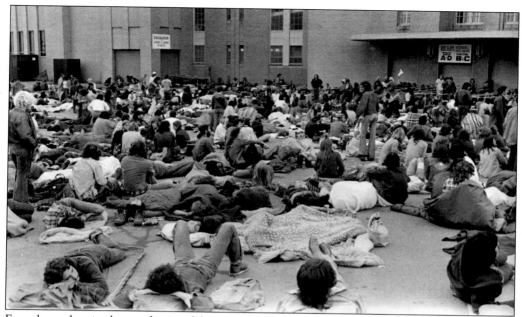

Fans showed up in the wee hours of the morning to camp outside the stadium before the "World Series of Rock" concert. While most party-goers were well behaved, there were enough incidents involving alcohol, drugs, and fireworks to warrant promoters to eventually ban "overnight guests." This put a damper on many partiers, though it did not totally stop the occurrences. (Cleveland Press collection.)

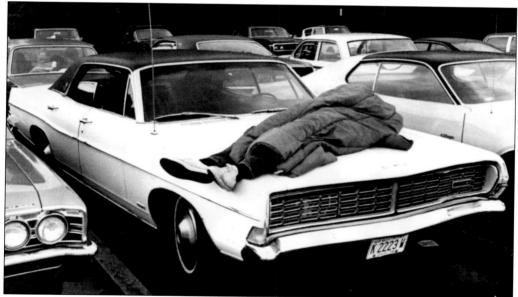

For some, the party took precedence over the musical offerings and before the concert ended (or even began) those who partied hardy passed out wherever they happened to be. Here, a concertgoer decides his car (or perhaps someone else's) was good enough to lie down for a little nap. But "The World Series of Rock" concerts ended on a high note in 1980 with Bob Seger and the Silver Bullet Band, Eddie Money, and J. Geils. (Cleveland Press collection.)

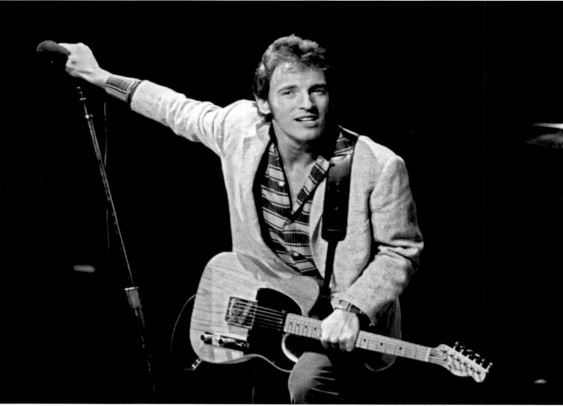

But perhaps no place rocked more than the Richfield Coliseum from 1974 until 1994. This venue presented a who's who list of notable rockers, such as Led Zeppelin, Kiss, The Rolling Stones, Van Halen, and Aerosmith, to name a few, but Bruce Springsteen (seen here performing at the Coliseum) was a Cleveland favorite. And the feeling is mutual for this Jersey rocker who has WMMS deejays David Spero and Kid Leo to thank for pushing his first album. After more than 20 years of rocking America, Springsteen was inducted into the Rock and Roll Hall of Fame in 1999. (Photograph by Janet Macoska.)

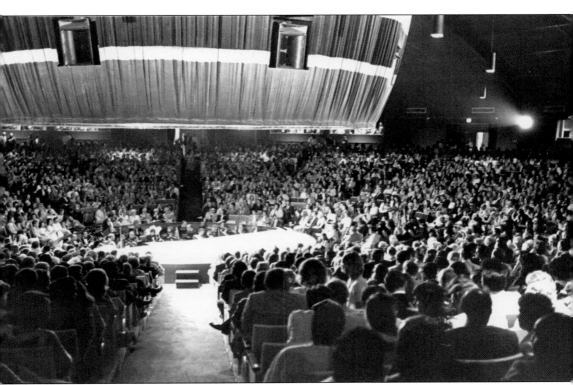

Front Row Theater opened in 1974 and was a personal favorite of those who enjoyed a more intimate atmosphere and a chance to get up close and personal with the music acts—which was possible no matter where you sat in this 3,200-seat venue. The revolving stage allowed a clear view for all attendees. Attractions included a wide range of entertainment from Frank Sinatra and Wayne Newton to Michael Jackson and Frank Zappa. But Clevelanders will never forget the four-night stand by hometown's The Michael Stanley Band, which broke attendance records each night in 1986. (Cleveland Press collection.)

While the Richfield Coliseum, the old Cleveland Stadium, and Front Row Theater no longer exist, Blossom Music Center continues to be a beloved summer attraction. Located in an idyllic rural setting in Cuyahoga Falls, Blossom, which opened in 1968, is the summer home of the Cleveland Orchestra, but also an attractive draw for rock and roll lovers. Picnics were a common sight here. The venue continues to host a variety of musical performers that include all genres, attracting all age groups, and is one of Cleveland music's true success stories. (Cleveland Press collection.)

Six

BLAME IT ON THE DEEJAYS, PART TWO

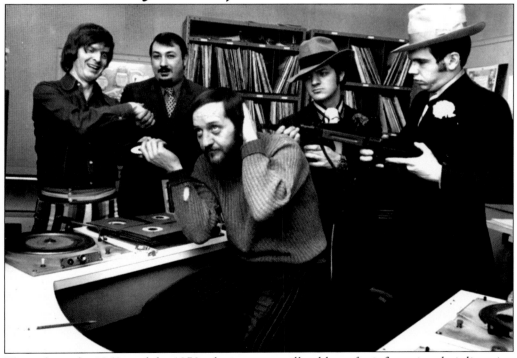

Throughout the 1960s and the 1970s, deejays were still to blame for influencing their listening audience by introducing them to new sounds, and oftentimes, evoking campy promotions. This 1971 photograph shows how WGAR's popular morning jock Don Imus (far left) "persuaded" his WMMS rival Dick "Wilde Childe" Kemp to play his new record. Imus would leave Cleveland and become one of the most controversial radio personalities in the country. (Cleveland Press collection.)

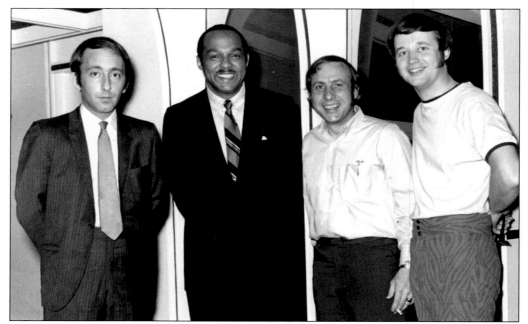

WIXY-1260 was so big in the early 1970s that even the mayor of Cleveland was a fan and visited the studios often. Here, Mayor Carl Stokes (second to left) stops by to speak to students at the WIXY School of Broadcasting. Deejays who welcomed him are, from left to right, Mike Reineri, Chuck Dunaway, and Chuck Knapp. Dunaway was a WKYC deejay before becoming WIXY's program director from 1969 until 1975. (Chuck Dunaway collection.)

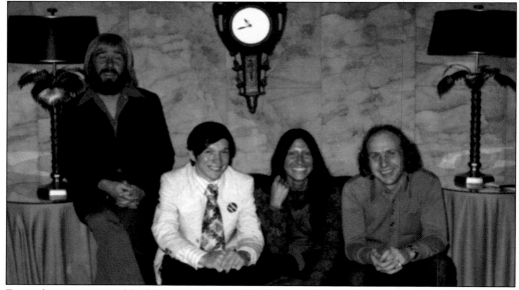

Even future mayors liked hanging out with deejays. Here, then–city councilman Dennis Kucinich (second from left) sits between an unidentified record promoter and singer Buffy Saint Marie, in town for a WIXY-sponsored concert. "Dennis secured us lots of help from the city and police department," Chuck Dunaway (far right) says. "He was a real friend of the station." (Chuck Dunaway collection.)

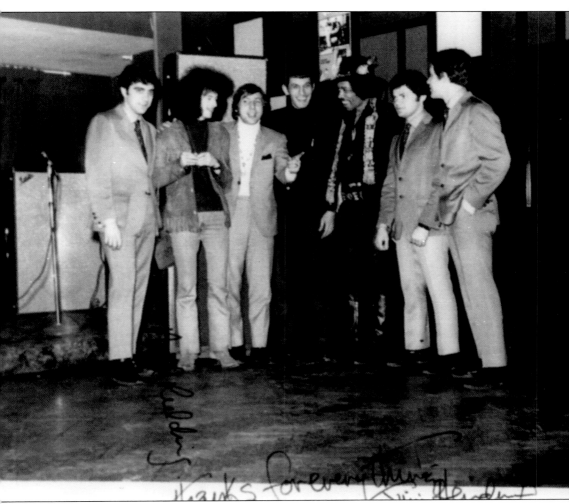

One of the perks of being a disc jockey was hanging out with rock stars. This impromptu get-together was an experience new WKYC deejay Chuck Dunaway will never forget. "The night before the group's concert at Public Hall, Jimi stopped in at Otto's Grotto [one of the hippest clubs in Cleveland]," Dunaway recalls. "Later, he spontaneously got on stage and just blew everyone away." Standing with some unidentified friends are Hendrix's bass player Noel Redding (second from left), *Star Trek* actor Leonard Nimoy (center, in town to promote a record he had made), and Jimi Hendrix (third from right). (Chuck Dunaway collection.)

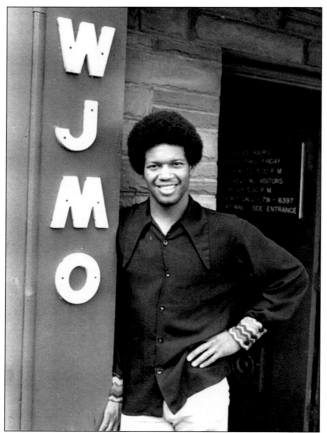

While "progressive rock" deejays were shaking up the music scene in the early 1970s, over at WJMO-AM, young Lynn Tolliver was keeping R&B alive by playing records by the Temptations, Aretha Franklin, Lou Rawls, Al Green, and hometown boys The O'Jays (whose name came from another WJMO deejay, Eddie O'Jay), and Bobby Womack. But Tolliver was also spinning rock—which included songs by Rod Stewart, Atlantic Rhythm Section ("Imaginary Lover") and more homegrown talents such as The Raspberries. During his shift of seven-to-midnight, "Shotgun," as he was called on the airwaves, helped make WJMO one of the hottest AM stations in the market. He eventually became the station's program director before moving on to Columbus and Chicago. He returned to Cleveland in 1982 to work at WZAK, staying for the next 18 years. He now resides in Florida. (Cleveland Press collection.)

In 1971, WIXY's Billy Bass became deejay and program director at WNCR-FM. A previously ignored radio band, FM was heading into the mainstream. Whereas AM spun out spit-polished tunes from pop, soul, and Motown to rockabilly and "lite-rock" sounds of the Top 40, FM offered long-playing and "hard rock" sounds not heard on AM radio. Bass's move, along with other hip deejays, convinced many that AM was no longer cool. (Cleveland Press Collection.)

WNCR-FM converted new listeners with deejays who loved turning them on to new music, as well as featuring a female disc jockey, a rarity back then. Shauna Zurbrugg (left) joined in 1971 and was given the morning-drive spot, with Jeff Gelb (right). After hosting her own Saturday night program for a time, Zurbrugg left, along with other colleagues, for WMMS. Gelb soon departed for San Diego. (Photograph by Anastasia Pantsios; Billy Bass collection.)

WMMS boasted enthusiastic, knowledgeable deejays who welcomed new artists. The 1972 staff included, from left to right, from top, Denny Sanders, Billy Bass, David Spero, and Joyce Halasa (seated), here with contest winner Jack Novesel (seated). Bass holds a plaque crediting the station for "breaking David Bowie in the U. S." "Bowie was a star in Cleveland long before the rest of the country caught on," Bass says. Whether anyone actually consumed the tequila, or it was strictly for publicity, is left to interpretation. (Photograph by Fred Toedtman.)

The 1974 WMMS staff was (standing): program director John Gorman, Steve Lushbaugh, Kid Leo, Jeff Kinzbach, Denny Sanders, Betty Korvan (left, seated), Ed "Flash" Ferenc, Jimmy Perdue, and Matt the Cat. The popular Jeff and Flash's *Morning Zoo* show would debut in 1976. (Photograph by Fred Toedtman.)

Betty Korvan was a familiar name and voice at WMMS. "A petite and reticent exterior containing a mouse that roared," as described by her boss, John Gorman. Korvan's nighttime shift, from 1:00 a.m. to 6:00 a.m., was a huge hit, sparking one of the station's top-selling T-shirts with, "I Wake Up with Jeff & Flash," on the front, and "I Go to Bed with Betty Korvan" on the back. (Courtesy of Betty Korvan.)

Nearly everyone had a nickname at WMMS: Len "Boom" Goldberg, Ed "Flash" Ferenc, "Kid Leo" Travagliante, "B. L. F. Bash" Freeman, "T. R." Rezny, and "Matt the Cat" Lapczynski. Betty Korvan got hers from the many "crashes" behind the wheel of her battered-up Gremlin. So Betty "Krash" Korvan (second from left) took on morning deejay Jeff Kinzbach (second from right) at Thompson Drag Raceway. They raced two-, three-, and four-wheelers. Korvan won every race. (Courtesy of Betty Korvan.)

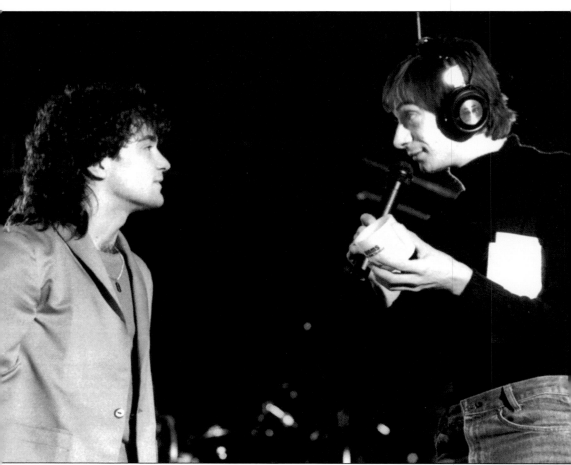

"Matt the Cat" Lapczynski joined WMMS in 1973 as the weekend announcer but soon became the midday jock and host of the Wednesday *Coffee Break Concerts*. These afternoon concerts ranged from local and regional acts such as the Michael Stanley Band, I-Tal, Wild Horses, and Breathless, to national artists like Bryan Adams, Foghat, and Artful Dodger. Here, Matt the Cat interviews singer Rich Spina, from local band Love Affair. (Photograph by Anastasia Pantsios; Courtesy of Rich Spina.)

It was always an event when a rock star came to town, and WMMS had most of them visit their studio. And even better when one was a hometown boy made good. Here, David Spero interviews Eric Carmen in 1973 on the heels of The Raspberries' third album *Side 3*. (David Spero collection.)

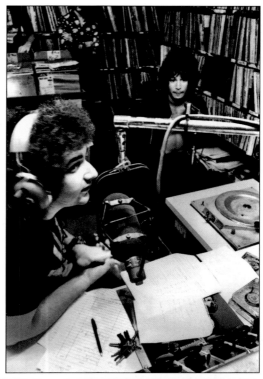

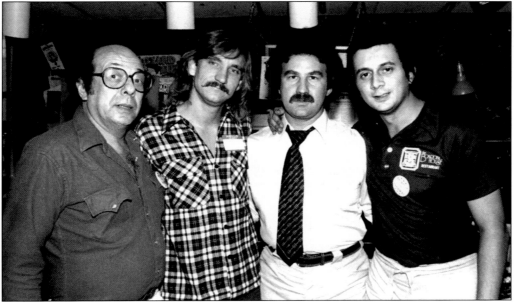

When this former Kent Stater stopped in at WMMS, it was cause to celebrate. Gathering for a photo op are, from left to right, salesman and WMMS personality Murray Saul, guitarist Joe Walsh, vice president and general manager Walt Tiburski, and deejay Kid Leo. "Joe visited the station often," recalls Tiburski. "He did guest deejay shots, station IDs—always a big 'MMS booster." (Courtesy of Walt Tiburski.)

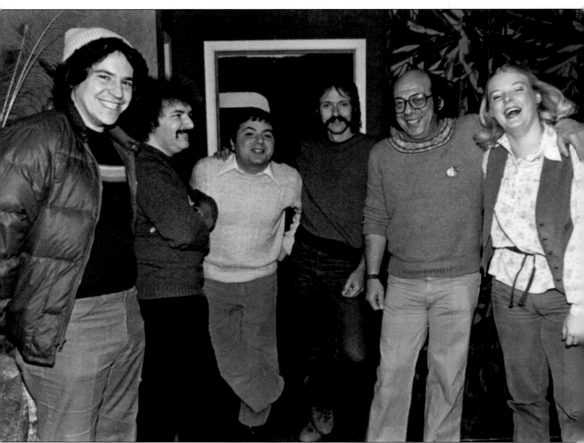

Despite the constant WMMS promotions that dominated the media, not everyone was tuning in solely to this major radio presence. The "other" hip rock station at the time was WWWM (M-105), which debuted in 1975 and for a time was WMMS's toughest adversary. (Program director Eric Stevens was every bit as competitive as his nemesis John Gorman.) But rock stars frequented both studios when promoting a new album. Here singer Jesse Colin visits M-105, posing with, from left to right, national album promotion director for Elektra-Asylum Records Burt Stein, M-105 deejay David Spero, Stevens, Young, regional Elektra-Asylum Records rep Murray Saul (best known for his Weekend Get-Down Salutes on WMMS), and M-105 music director Ellen Roberts. (David Spero collection.)

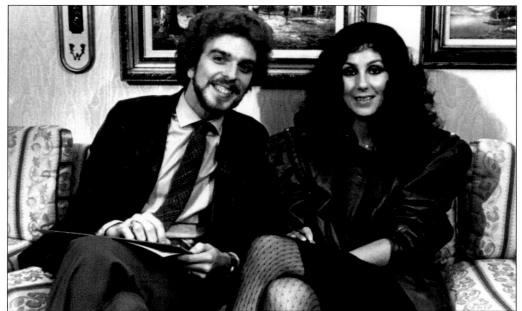

Formerly a WIXY deejay, Tim Byrd, "The Byrdman," became best known from his days as a "G-98" (WGCL) personality. He was a familiar sight at concerts and often conducted interviews for his show (he is seen above interviewing Cher). But greater local fame would come in 1979 when he was hired to be the host of a new television disco dance show, *Weekday Fever*. The show, however, would have a short life. Byrd would transfer to New York in 1980. (Above, photograph by Janet Macoska, courtesy of Tim Byrd; below, Cleveland Press collection.)

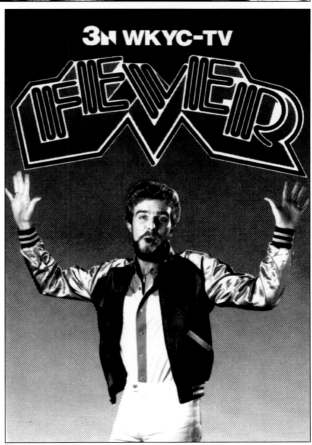

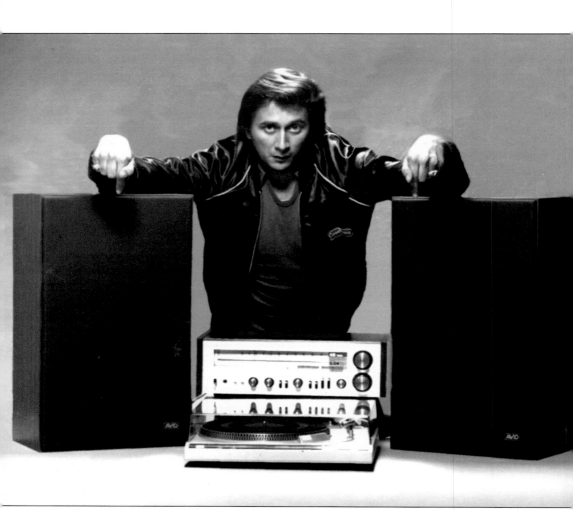

But there was no one who held radio court like WMMS jock Kid Leo. His great love for music and his signature voice and style would make him a favorite among listeners for 16 years. He started at college radio station WCSU (Cleveland State University) before joining the crew of young deejays at WMMS. He soon became the music director and in 1980 was named one of *Rolling Stone's* "Heavy Hundred: The High and Mighty of the Music Industry." He also combined his love for music with his love of sports and introduced a new concept in radio, a segment of his afternoon show called "The Bookie Joint" in which he interviewed sports figures on his rock show, luring even more listeners to the station. The beloved deejay left for New York in 1986 and currently is a deejay and program director for the *Undergound Garage* show on Sirius Satellite Radio. He is also featured in the broadcast wing of the Rock and Roll Hall of Fame. (Cleveland Press collection.)

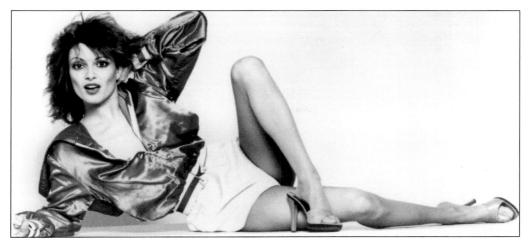

Nina Blackwood was involved in a number of entertainment fields before becoming one of the first "Veejays." In her youth, she acted in plays at Lakewood's Little Theater, played classical harp, and was a model (seen here). In 1978, she appeared in *Playboy* magazine before moving to Los Angeles with her musician boyfriend Danny Sheridan from the Eli Radish band. In 1980, she auditioned for a new music/television concept program and became the highly recognizable face in the early days of MTV. She went on to host her own "Rock Report" for *Entertainment Tonight* as well as the hit dance show *Solid Gold*. Sheridan continues to manage her career and produces her long-running syndicated shows *Absolutely 80s* and *Nina Blackwood's New Wave Nation* on Sirius-XM Satellite Radio. (Courtesy of Danny Sheridan.)

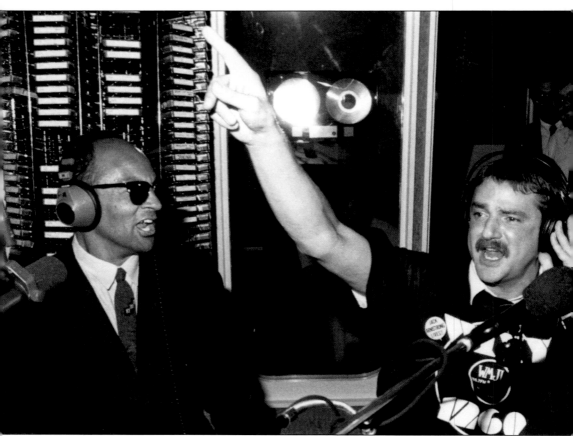

As powerful as WIXY was in the 1960s through the 1970s, it could no longer compete with the monster that was FM radio (which by 1976 dominated the major demographic of 18–35 year olds). But veteran fans of a radio era long gone welcomed the WIXY reunion in 1997 at oldies radio station WMJI. The former deejays, too, were all too happy to reminisce. Here, Billy Bass (left) is thrilled to share the mike with old radio colleague and friend Big Jack Armstrong, who had come up from North Carolina. "Jack had the best voice in radio, and was the greatest Top 40 deejay ever," Bass says of Armstrong, who died in 2008. "He may not have invented the style, but he perfected it. Nobody was quicker on their feet, faster on the mike, more exciting than he was. If there was art in what we did, he was Picasso and I was some newbie on an etch-a-sketch." (Billy Bass collection.)

Seven

ROCKIN' MUSICIANS OF THE 1970s

The Michael Stanley Band is Cleveland's most beloved. The group began in 1974 playing at places like the Agora, but soon spread its wings across the United States, including tours and appearances on *American Bandstand* and MTV. Its 23-year history gave fans 11 albums and numerous fond memories. This 1977 photograph features, from left to right, Bob Pelander (keyboard/vocals), Dan Pecchio (bass), Michael Stanley (guitar/vocals), manager David Spero, Tommy Dobeck (drums), and Jonah Koslen (guitar). (David Spero collection.)

Through those Michael Stanley Band years, the group released several hits songs, such as "He Can't Love You," "My Town" (an MTV favorite), and "Lover," and toured throughout the country, opening for the Eagles, Doobie Brothers, and Bruce Springsteen. But the Michael Stanley Band was always the headlining act in Cleveland, with renowned national musicians opening for them, such as Billy Joel, Cheap Trick, and John Cougar Mellencamp. They continuously sold out concerts at Blossom (the group holds the attendance record there) and the Coliseum. But in 1986, the group lost its EMI recording contract and was forced to call it quits soon after. However, Cleveland's favorite sons gifted their longtime fans with 12 straight rocking "farewell" shows (each sold out) at the Front Row. Stanley went on to co-host the *PM Magazine* television show, and became a radio deejay, first at WMMS and then WNCX in 1992. He continues making music and releasing albums, and remains the afternoon-drive deejay at WNCX. (Photograph by George Shuba.)

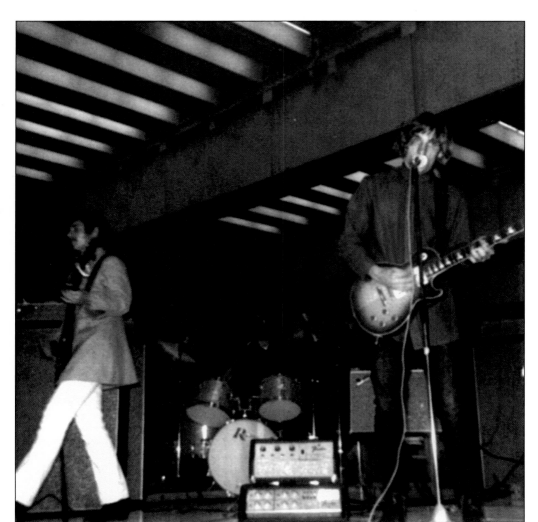

In 1969, the popular five-member James Gang became a power trio. When Glenn Schwartz left for the west coast, his replacement came knocking—literally. "Glenn had left the band on a Sunday," founder Jim Fox recalls, "and that Monday I get this knock on my apartment door." When Fox opened it, there stood Joe Walsh, who said simply, "I hear you're looking for a guitar player." Both were students at Kent State University and, along with bass player Tom Kriss (seen here at left, and replaced in 1970 by former member of the E. T. Hooley band Dale Peters), the group broke fast with hits such as "Funk #49," "Walk Away," and a fondly remembered European tour opening for The Who. "Once we'd gotten off that Who tour, we too started getting a little crazy, you know, jumping off our amps, smashing equipment, creating general havoc," Peters recalls. "We had some great times with those guys." By 1971, this gang was a household name in the world of rock. (Gene Schwartz collection.)

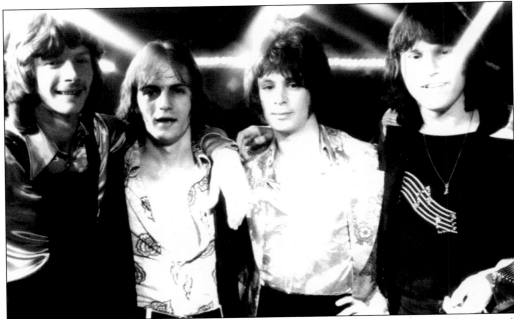

The Raspberries formed in 1970 and quickly secured a Capitol Records contract. The quartet's debut album included *Billboard* hits "Don't Want to Say Goodbye" and "Go All The Way." A European tour followed, along with appearances on television shows *Don Kirshner's Rock Concert* and the *Midnight Special*. Other hits included "I Wanna Be With You," "Let's Pretend," and "Tonight." The original power pop quartet included, from left to right, Dave Smalley (bass guitar), Jim Bonfanti (drums), Eric Carmen (lead singer/guitar/keyboards), and Wally Bryson (guitar/vocals). (Courtesy of Jim Bonfanti.)

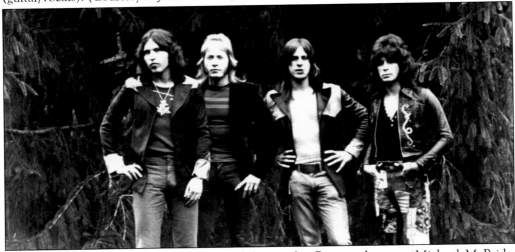

The line-up changed in 1973 with, from left to right, Bryson, drummer Michael McBride, guitarist Scott McCarl, and Carmen. They recorded *Starting Over*, which generated the hit single, "Overnight Sensation." The group disbanded in 1975, but the original formation reunited in 1999 for *Plain Dealer* reporter Jane Scott's 80th birthday party. The response was so great, the Raspberries now do concerts whenever their schedules permit—much to the delight of their long-time fans. (Cleveland Press Collection.)

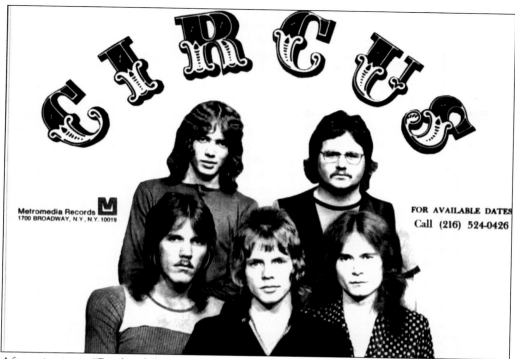

After winning a "Battle of the Bands" contest in 1971, Circus, with (top, clockwise) Tommy Dobeck (drums), Dan Hrdlicka (lead guitar), Frank Salle (bass), Phil Alexander (lead singer), and Mick Sabol (rhythm guitar) won an RCA recording contract and immediately went into the studio. Their record, "Stop Wait, and Listen" (penned by Hrdlicka) made it to *Billboard*'s Top 100 and was a personal favorite of New York deejay Murray the K. (Courtesy of Dan Hrdlicka.)

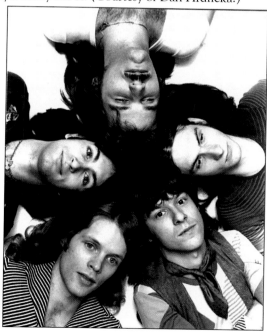

The last line-up of Circus in 1974 was (clockwise from bottom) Phil Alexander (lead singer), Norm Isaac (bass/vocals), Mick Sabol (guitar/vocals), Stu Leyda (drums), and Al Globekar (guitar/vocals). (Courtesy of Norm Issac.)

101

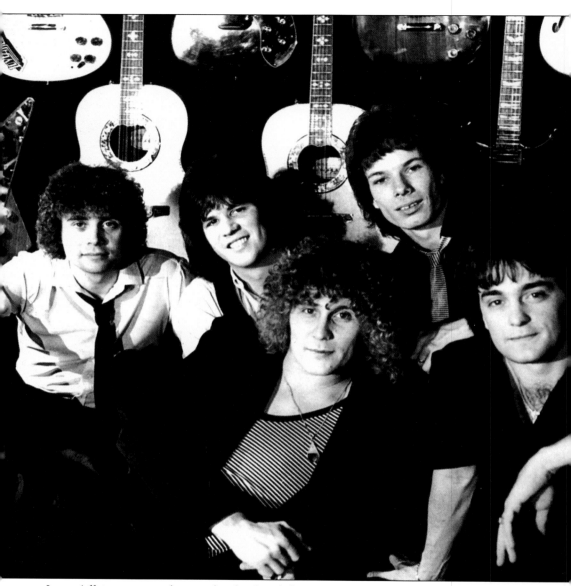

Love Affair was a good name for this band that captured the hearts of fans in and outside of Cleveland. Although starting out as Brick, then Skyport, then Stairway, this quintet known as Love Affair was a big draw in clubs throughout Ohio and beyond (they were especially popular throughout Florida) from 1976 to 1983 (in their final year in 1984 they were known as Unknown Stranger). This power pop rock band, with, from left to right, Wayne Cukras (bass), Mike Hudak (drums) Wes Coolbaugh (guitar), John Zdravecky (guitar), and Rich Spina (vocals/frontman) was known for its powerful Led Zeppelin songs, and for packing the house at the Cleveland Agora. The group's first LP, self-titled, was produced by Peter Schekeryk, husband to singer Melanie ("Brand New Key"). The biggest single off this album was "Mama Sez," which received extended airplay on rock radio. After two more albums, the group broke up. Since then, Rich Spina has played in oldies bands, Gary Lewis and the Playboys, and is currently in Herman's Hermits. (Photograph by Anastasia Pantsios; Courtesy of Rich Spina.)

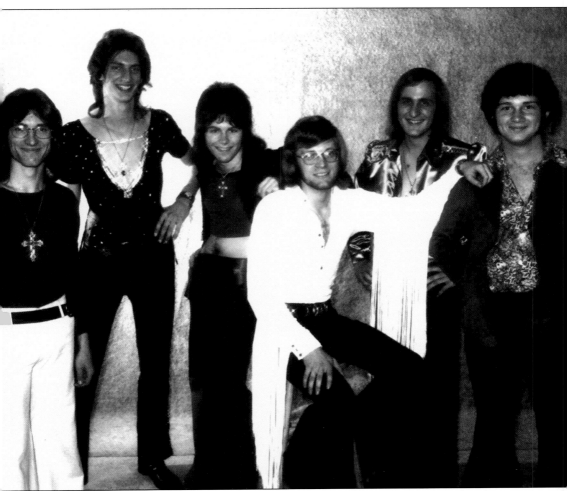

Bluestone Union formed in 1971 and for the next several years was a fixture on the local music scene playing danceable hard rock, with songs by The Rolling Stones, The Beatles, The Who, Humble Pie, Led Zeppelin, Small Faces, David Bowie, and even Alice Cooper, along with some originals. Early members included, from left to right, Bill Callaghan (rhythm guitar/vocals), Wally Gunn (drums/vocals), Gary Braden (bass/guitar/keyboards/vocals), Mike Kwitowski (lead vocals/percussion), Ron Sukalac (lead guitar/vocals), and Kirt Campbell (keyboards/vocals). The group, with their harmony-driven British/American rock sound, opened often for the Raspberries before the latter became a national success. In 1974, the group shortened its name to simply Bluestone, along with a change in personnel (new members included Mark Avsec, A. J. Robey, Alan Retay, and Mike Gerchack) and obtained manager and booking agent Jim Quinn, formerly of Damnation of Adam Blessing, before ultimately disbanding for good. (Courtesy of Wally Gunn.)

Wild Horses was, and still is, a no-frills rock and roll band. Formed in 1974, the group plays music as diverse as The Doors, Santana, and The Allman Brothers. Despite being known as a cover band, their 1980 original hit song "Funky Poodle" (penned by later member Steve Jochum) will forever be their legacy. Posing in an apt setting are Andy Leeb (guitar), Roger Kleinman (bass), Billy Buckholtz (keyboards), Rob Goldfarb (guitar), and Dennis Christopher (percussion). Drummers have included Bruce Ark, Rick Sustaric, and Tony Mazzone. (Courtesy of Bill Buckholtz.)

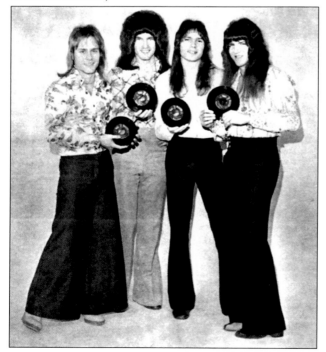

Rapscallion played melodic pop sounds of the day, but also recorded originals. This included the 1975 "Sorry If I Lied To You," the 1979 "Just a Rapscallion," and the 1980 "Anytime"—all of which received radio airplay. While the quartet did not receive the national notice they desired, this band enjoyed many years as a local favorite. (Courtesy of Brad Bell.)

Cleveland native Neil Giraldo (left) played in local bands through the 1970s, most notably Lovers' Lane. After a stint with Rick Derringer, his career—and personal life—changed in 1977 with a phone call. "I was heading home from New York when I got a call from an A&R man looking to put a band together for a female singer they'd just signed," he recalls. The singer was Pat Benatar, and from that moment on, Giraldo would never live in his hometown again. The hit songs came fast: "Heartbreaker," "Treat Me Right," "You Better Run," "Fire and Ice," "Hit Me with Your Best Shot," and the Grammy-winning album *Crimes of Passion*. Each of these hits demonstrate Giraldo's distinctive guitar licks, and combined with Benatar's equally distinctive vocals, the dynamic duo became one of rock's most recognized musical couples. The two visit Northeast Ohio often to perform at venues such as Blossom, but also to see family and old friends. Here he and Benatar are greeted in 1993 by WMMS deejay Mike Olszewski. (Photograph by Brian Chalmers.)

In 1978, former Michael Stanley Band member and prolific songwriter Jonah Koslen formed this band of talented and experienced musicians. Like many, Breathless experienced early line-up changes (it began as a quintet with female singer Susan Lynch). But by 1980, the group seemed established, as did its reputation as one of the hottest Cleveland bands. The first album on EMI America Records garnered a *Billboard* Top 100 single, "Takin' It Back," but also featured other favorites: "Glued to the Radio" and "Walk Right In." The band's next album, with the song "Wild Weekend," did not fare as well and by 1981, the disillusioned group went their separate ways. "The lack of national success was disappointing," Koslen says. "But I'm proud of what we were able to accomplish in that short period." Breathless members, standing in one of Cleveland's beautiful downtown arcades, included, from left to right, Mark Avsec (keyboards), Bob Benjamin (bass), Jonah Koslen (lead vocals/guitar), Kevin Valentine (drums), Rodney Psyka (percussions/vocals), and Alan Greene (lead and rhythm guitar). (Courtesy of Alan Greene.)

Pittsburgh and Cleveland may be rivals in football, but this combination made for a harmonious liaison. Cleveland musician Mark Avsec (Breathless/Wild Cherry) and Pittsburgh singer Donnie Iris (The Jaggerz, of the 1970 hit "The Rapper"), decided to form a new band together in 1979. "I wanted to be more involved in the production and songwriting process," Avsec says. They formed Donnie Iris and the Cruisers with, from left to right, Marty Lee Hoenes (guitar/background vocals), Donnie Iris (lead vocals), Paul Goll (bass/background vocals), producer Mark Avsec (keyboards/background vocals), and Kevin Valentine (drums). After securing management with Belkin-Maduri Productions, the group went into the studio and began recording. Their 1981 song "Ah! Leah!" made it to number 29 on *Billboard* and still gets plenty of airplay. To date, the group has released 14 albums, and still plays the concert circuit, often pairing with former members of the Michael Stanley Band. (Photograph by Janet Macoska. Courtesy of Mark Avsec.)

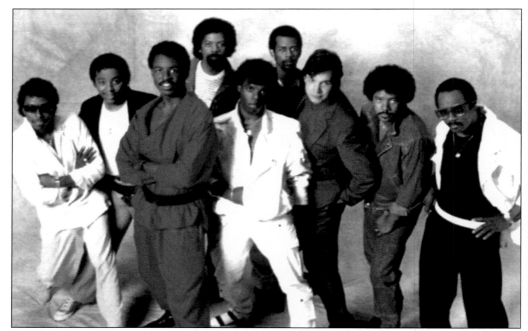

This group underwent several changes in its 14-year history, but its distinct sound—an electrifying mix of R&B, jazz, soul, pop, and funk—was always a crowd pleaser. The Dazz Band (originally Kinsman Dazz) first signed with Twentieth Century Fox Records, then hopped on board Motown Records, releasing "Invitation to Love" (penned by guitarist Michael Calhoun) in 1980. In 1982, their single "Let it Whip" hit no. 1, and was a favorite on *Soul Train*. (Author's collection.)

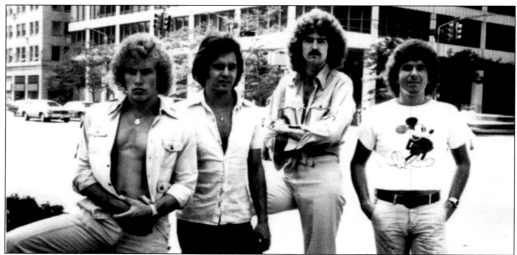

Wild Cherry's song "Play That Funky Music (White Boy)" is perhaps the most widely played and easily recognized record in pop music history. The song came to founder/guitarist Robert Parissi at a gig when he heard drummer Ron Beitle say, "You white boys gonna play some funky music?" Parissi wrote the lyrics that evening. The group, from left to right, is Ron Beitle (drums/vocals), Allen Wentz (bass/vocals), Bryan Bassett (guitar/vocals), and Rob Parissi (guitar/lead vocals). (Courtesy of Rob Parissi.)

Eight

GENRES OF ROCK, CLEVELAND STYLE

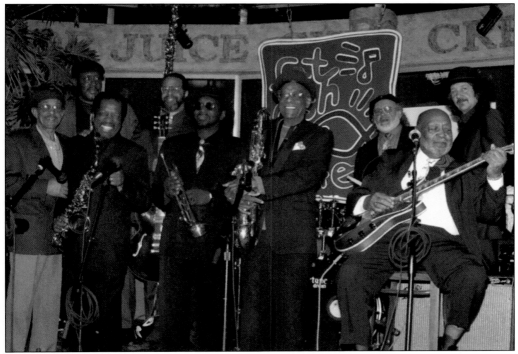

Rock and roll is derived from many different sounds: bluegrass, folk, jazz, and country, but it was the blues that was its driving force. Cleveland, rich in musical diversity, is an enthusiastic blues town, thanks in no small part to Robert Lockwood Jr. (far right). His All-Star Band (seen here) toured extensively but its leader always considered Cleveland home. The Grammy-winning bluesman died in 2006, but his band lives on every Wednesday night at the downtown music venue Fat Fish Blue. (Courtesy of Gene Schwartz.)

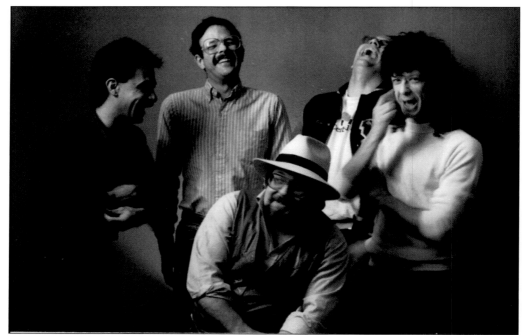

The Mr. Stress Blues Band, founded by harp player/singer Bill Miller in 1966, experienced many incarnations in its 30-plus years. Its most prominent era was the 1980s with regular Saturday night gigs at the Euclid Tavern. The formation here included, from left to right, Nick Tranchito (drums), Mike Sands (keyboards), "Stutz Bearcat" (bass), Alan Greene (guitar) and Miller (seated). "Mr. Stress"—known for his wise-cracks that keep fans and bandmates in stitches—currently plays in the Alan Greene Band. (Courtesy of Bill Miller.)

Jimmy Ley and the Coosa River Band played the blues at many local (Viking Saloon, the Mistake) and national venues throughout the 1970s. Ley's career spanned nearly 40 years. In 1991, he wrote the award-winning song "Pay Me in Cash," a fitting lament to musicians who experienced getting stiffed (or offered a check) at the end of a hard night of playing. (Courtesy of Jimmy Ley.)

Eli Radish is considered the first true country rock band in Cleveland. Members Danny Sheridan (bass), Tom Foster (guitar and pedal steel), Skip Heil (drums), and Ken "The Rev" Frak (lead vocals) formed in 1968 as a "radical/country/hippie/biker/rock band." Their unique style of blending country/western sounds with rock and roll was a big hit on the college tavern circuit. The group's reputation spanned all the way to Los Angeles, getting them noticed and signed with Capital Records. The resulting album, *I Didn't Raise My Boy to be a Soldier* consisted of famous war songs, in keeping with the anti-war sentiment of the era. In 1970, country rebel David Allan Coe (an Akron native) joined the party and the eccentric group earned a large dedicated following. In 1973, however, the members went their separate ways. (Courtesy of Danny Sheridan.)

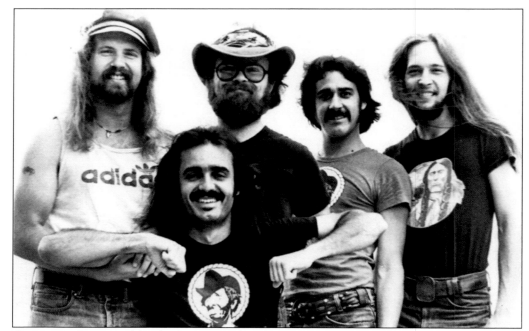

Country rock was cool by the late 1970s, but then, Clevelanders had known that for years. In 1973, Flatbush was formed, which mixed country sounds with rock, the likes of Lynyrd Skynyrd, The Eagles, and Pure Prairie League. They also recorded original songs that got local airplay. Flatbush featured, from left to right, Linn Roath (rhythm guitar), Larry Rice (bass and fiddle), Russ Gall (vocals), Joe Dickey (drums), and Phil Barker (guitar). (Cleveland Press collection.)

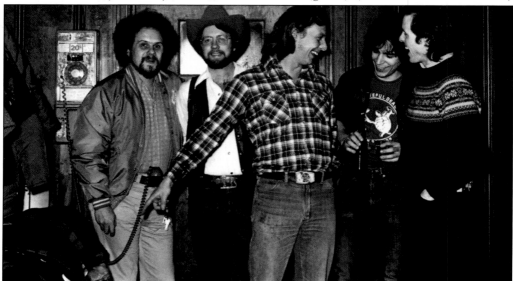

Deadly Earnest and the Honky Tonk Heroes was everywhere on the local music scene from 1975 to 1983. Lead singer/founder Denny Earnest's voice defined the band's sound and was instantly recognizable. Always in demand, the group often played six nights a week while holding down day jobs. Their songs "Wheeler Inn Cafe," "Leaving for Texas," and "Don't Make Me Laugh While I'm Drinking," were particular favorites. (Courtesy of Dennis Earnest.)

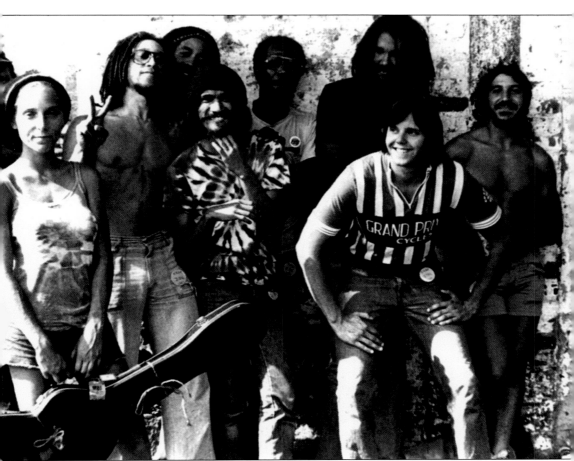

Reggae rock began in Cleveland with I-Tal in 1978, thanks to a Key West trip bar owner Dave Valentine took that year. "That's where I got turned onto Reggae," he recalls. He then put together a band like no other. I-Tal means vital, natural; as in the natural movement of the body when it hears music. And the crowd certainly moved to the group's Jamaican sounds. The nine-piece band enjoyed a large following, as did its sister band, First Light (formed in 1984 by several I-Tal members). Both groups made lasting impressions with recordings that remain hot items today. The line-up here includes, from left to right, founder Valentine, Ellie Nore (vocals), Carlos Jones (percussion/vocals), Mike "Chopper" Wasson (lead guitar), Chris Dunmore (drums), George Gordon (percussion), Dave Smeltz (guitar/vocals), Steve Mauer (trumpet), and Bob Caruso (congos, percussion). The group called it quits in 1994, but enjoy reuniting every couple of years. Jones now fronts his own band, Carlos Jones and the P.L.U.S . Band (Peace, Love and Unity Syndicate). (Courtesy of Carlos Jones.)

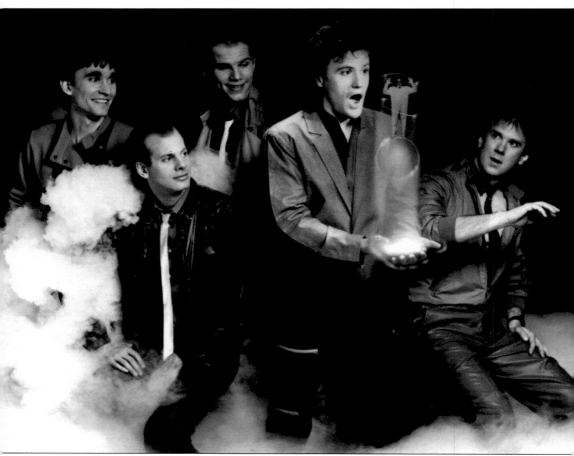

Theatrical rock was still a novelty in the mid-1970s with The Who, Genesis and Kiss just beginning to experiment with this new concept of a more dramatic and elaborate concert production. Once again, Cleveland was on top of the trend with Fayrewether. Formed in 1974, this band, lead by singer Paul Fayrewether, was the first to develop a whole show with costume changes to accompany their repertoire that featured songs by Genesis, Alex Harvey, and the Tubes. "I'd have my theater friends design wild costumes and props for our show," Fayrewether recalls. The result was a compelling rock show. A few favorites included a silver television set the frontman would wear on his head for the song, "Don't Let the Television Turn You On," and a black stocking mask for his version of the Alex Harvey song "Man in a Jar," The group released several original recordings and toured through the 1980s and early 1990s. Their 1994 breakup did not last, and Fayrewether still performs before packed audiences. (Courtesy of Paul Fayrewether.)

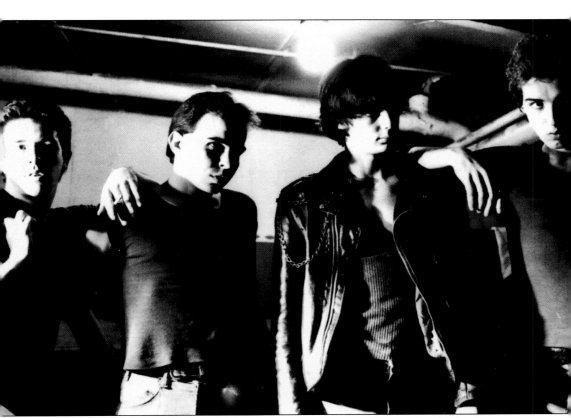

The Punk Rock trend began early in the decade in New York, Detroit, and Cleveland, though it remained underground through much of those embryonic years. The Cleveland punk scene began with bands such as Rocket from the Tombs, Pere Ubu, the Mirrors, Electric Eels, Cinderella Backstreet (featuring pioneering musician and writer, the late Peter Laughner), the Dead Boys, and The Pagans. Clubs that were receptive to this alternative, underground music included the Viking Saloon, Pirate's Cove, and Phantasy nightclub in Lakewood. These venues offered these spirited musicians a place, and stage, to emancipate their musical angst. Pagan members here are, from left to right, Brian Hudson (drums), Mike Hudson (guitar), Mick Metoff (guitar), and Tim Allee (bass). (Photograph by Tony Morgan; courtesy of Mike Hudson.)

Heavy metal also got an early start in Cleveland, with bands Raven Slaughter and Snake Rock. After a stint in Slaughter, guitarist Cristian Cremona (who changed his name to Snake Rock) formed his own band in 1978 with guitarist "Spike" Wray. They brought in Wray's brother Jeff on bass, and, after earlier drummers came and went, Bert "Crash" Atkins came and stayed. Snake Rock was known for its original songs, elaborate stage shows, and "snake" look (snakeskin-covered equipment, the frontman's trademark snake vest, and a 15-foot long snake that hung over the drums). By the 1980s, heavy metal would be a popular genre in Cleveland, with much help from Auburn Records founder Bill Peters, whose "Metal to Metal" program on college station WJCU (John Carroll University) continues to inform fans on what is happening in the heavy metal music scene. (Photograph courtesy of Betty Beitzel.)

Nine

MUSICAL MOVERS AND SHAKERS

Steve Popovich (left of center) is a staunch music lover and astute record promoter. He was the youngest VP of promotions at CBS Records, then headed Epic Records A&R department, where he was instrumental in many artists' successful releases (including Michael Jackson's *Thriller*). As founder of Cleveland International Records (1977), he steadfastly promoted Meatloaf's debut album. Here, he celebrates the success of that effort, when *Bat Out of Hell* went platinum. (Courtesy of Steve Popovich.)

Steve Popovich (left) and his Cleveland International Records label was largely responsible for the success of musicians such as Ted Nugent, Ronnie Spector, Boston, REO Speedwagon, Cheap Trick, Southside Johnny, Meatloaf (third from left), and Clevelander Roger Martin (fourth from right), among others. Club Promoter Hank LoConti (third from right) also had a hand in Meatloaf's exposure. (Photograph by Brian Chalmers.)

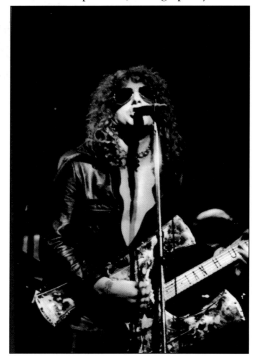

Cleveland's many music movers and shakers, as well as its reputation for enthusiastic and loyal fans, prompted British singer Ian Hunter to write the 1979 song "Cleveland Rocks" as an appreciative nod to the city. Mayor Dennis Kucinich then returned the honor by giving Hunter the key to the city. The song has become a virtual rock anthem. (Photograph by Fred Toedtman.)

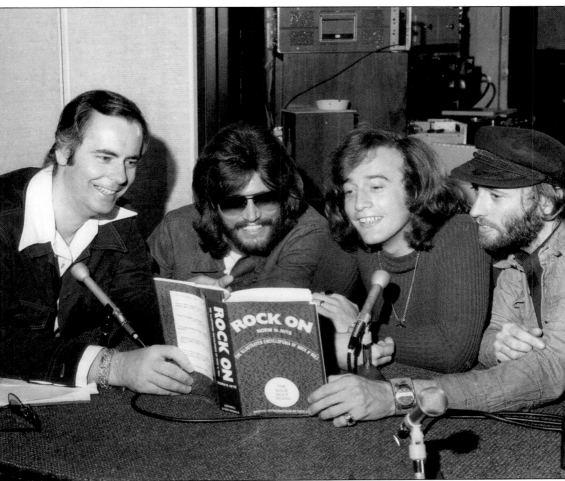

Norm N. Nite is called "Mr. Music" for a reason. His radio career has spanned more than 40 years across two big cities and numerous radio stations. He started out in 1970 at Cleveland's WGAR, playing the rock and roll he grew up with in the 1950s. By 1973, he was spinning tunes on New York station WCBS-FM. He not only played the music, he often told the stories behind the music, which won him many fans who encouraged him to chronicle all his interesting facts in a book. His *Rock On: the Illustrated Encyclopedia of Rock 'n' Roll* was released in 1974 (here, Nite, left, shows his book to the Bee Gees). Two more *Rock On* volumes followed, as did more radio jobs in both New York and Cleveland. In 1983, Nite led a tireless campaign to get the rock hall built in Cleveland. (Courtesy of Norm N. Nite.)

Hank LoConti is one of the most enduring and respected businessmen in Cleveland. Aside from his legendary Agora clubs (totaling 13 across the country at one time), LoConti (left, with John Magnus, getting ready to open his first club near Case Western Reserve University), also operated a disco club called the Rare Cherry, an outdoor concert venue, Buckeye Music Center near Columbus, and had his own record company, Agora Records. His reputation for opening the door to new music and musicians is known throughout the world (he even had a club in Russia called Hollywood Nites). LoConti, now 79, shows no signs of retiring. His Agora Theater and Ballroom continues to rock in this rock and roll city. (Cleveland Press collection.)

Jules and Mike Belkin have been making things happen in Cleveland for more than 40 years. Belkin Productions Inc. began in 1966, and since then the Belkin brothers have enjoyed an impressive career that has expanded in many ways, including artist management and record producing. By the end of the 1970s, theirs was one of the three top promotional companies in the country. The name Belkin is now synonymous with the music industry. (Cleveland Press collection.)

Concert tickets are always in demand. And the Belkins were the ones to get them into fans' hands. Here Jules Belkin holds up tickets to one of the hottest acts in 1971, Elton John. (Cleveland Press collection.)

Plain Dealer rock reporter Jane Scott always had a backstage pass. After convincing wary *Plain Dealer* supervisors to let her write about rock acts, Jane covered it all in her weekly column. She reported on new acts as well as the established. On May 3, 2009, she celebrated her 90th birthday. (Photograph by Brian Chalmers.)

In 1997, Jane Scott was honored by the Rock and Roll Hall of Fame. The esteemed rock reporter earned respect and love from the biggest of rock stars, whose question upon landing in Cleveland was always, "Where's Jane?" (Photograph by Janet Macoska.)

Ten

HAIL, HAIL HALL OF FAMERS

Although he was born in Kansas and raised in Columbus, Ohio, and New Jersey, Joe Walsh considers himself a bona fide Clevelander. This is where he honed his musical mastery while attending Kent State University and playing in nearly every music venue on the North Coast. He was inducted into the Rock and Roll Hall of Fame with The Eagles in 1998. (Photograph by Fred Toedtman.)

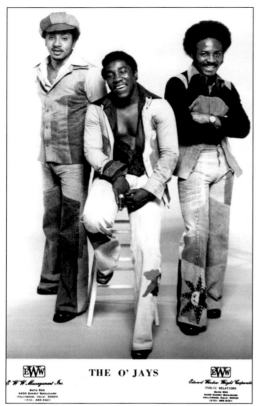

THE O'JAYS

The O'Jays came into prominence in the early 1970s, but the group had been around much longer than that. Inspired by Frankie Lymon and the Teenagers, the classmates from Canton McKinley High School started singing doo-wop and began performing in the late 1950s at YMCA dances and sock hops, then on to the local pubs. Soon, the group (who had changed their name from the Triumphs to the O'Jays to honor Cleveland deejay Eddie O'Jay for his steadfast support) became regulars at Cleveland's top R&B club, Leo's Casino, and began recording. Their first no. 1 hit, "Backstabbers" in 1972, was quickly followed by more hit records, including "Love Train," "Use Ta Be My Girl," and many others. Along with other accolades, such as the Pioneer Award (R&B's highest honor), the group was inducted into the Rock and Roll Hall of Fame in 2005. (Cleveland Press collections.)

Chrissie Hynde taught herself to play guitar as a teenager in Akron after seeing Mitch Ryder and the Detroit Wheels. She began singing in Mark Mothersbaugh's band (way before Devo), then formed a band called Jack Rabbit. She spent some time in Cleveland as a cocktail waitress at the trendy club Last Moving Picture Show. Growing restless, she eventually moved to England, where she formed The Pretenders in 1978. "Brass in Pocket (I'm Special)" became a hit in both the United Kingdom and the United States. Other hits include "Back on the Chain Gang," "Middle of the Road," and "My City Was Gone." The Pretenders was inducted into the Rock and Roll Hall of Fame in 2005. Today, Hynde spends much of her time in her hometown after opening a vegan restaurant there in 2007. (Author collection.)

It was particularly gratifying when a hometown-boy-made-good could return to his old stomping grounds and perform at the city's hottest club. In January 1970, Bobby Womack and His Revue played Leo's Casino. While Womack's hometown musical colleagues The O'Jays were staples there, this was Womack's first appearance at the legendary club. By the time he returned to perform in Cleveland in 1985, the self-described "last of the soul men" was a major recording artist. (Cleveland Press collection.)

But no homecoming could be better for Bobby Womack than to return to Cleveland as a Rock and Roll Hall of Fame inductee. His career began with the legendary Sam Cooke, who he often opened for and who became his mentor and friend. The singer/guitarist was also a prolific songwriter, writing the Rolling Stones' first U.S. hit "It's All Over Now" among hundreds of others. Here he greets fans at the rock hall before his induction in 2009. (Photograph by Jeff Adams.)

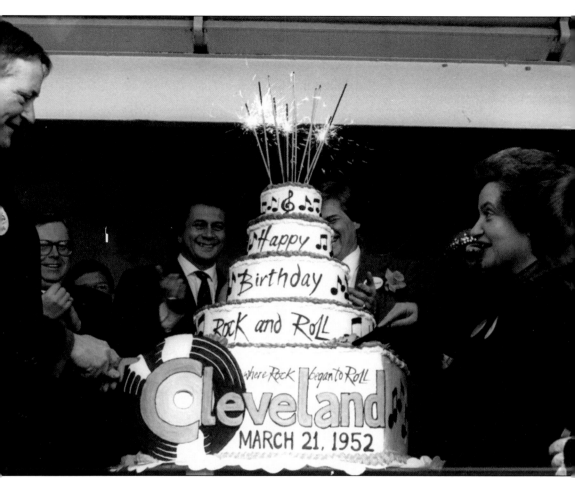

In 1985, the country was all abuzz over the concept of a rock and roll hall of fame. Clevelanders quickly presented dozens of valid reasons why their city should be its home. Radio stations pumped up the volume and after 110,315 people voted for Cleveland in a *USA Today* poll, the party began. On March 21, 1986 (the 34th anniversary of the Moondog Coronation Ball), there were tons of musical celebrations throughout the Greater Cleveland area. Concerts included performances by Chuck Berry, Chubby Checker, and Eric Carmen. Norm N. Nite hosted a rock 'n' roll birthday bash at the Palace Theater. Here, Ohio governor Dick Celeste and Congresswoman Mary Rose Oakar—avid supporters of the campaign—cut the celebratory cake. The rock hall opened on September 1, 1995, with national live television and radio coverage, a "Rockin' in the Streets" parade, and a Saturday night all-star concert. The weekend-long festivities left no doubt that, from its roots that began in the 1950s, Cleveland always has, and always will, rock. (WMMS archives.)

DISCOVER THOUSANDS OF LOCAL HISTORY BOOKS FEATURING MILLIONS OF VINTAGE IMAGES

Arcadia Publishing, the leading local history publisher in the United States, is committed to making history accessible and meaningful through publishing books that celebrate and preserve the heritage of America's people and places.

Find more books like this at
www.arcadiapublishing.com

Search for your hometown history, your old stomping grounds, and even your favorite sports team.